Pittman

HOWARD N. FOX

**WITH CONTRIBUTIONS BY
DAVE HICKEY AND PAUL SCHIMMEL**

LOS ANGELES COUNTY MUSEUM OF ART

This volume was published in conjunction with the exhibition *Lari Pittman*, organized by the Los Angeles County Museum of Art. The exhibition was supported in part by grants from the Lannan Foundation, the National Endowment for the Arts, and the Peter Norton Family Foundation.

Exhibition itinerary

Los Angeles County Museum of Art
June 23–September 8, 1996
Contemporary Arts Museum, Houston
November 1, 1996–January 5, 1997
Corcoran Gallery of Art, Washington, D.C.
February 8–April 7, 1997

The following works were included in the Los Angeles presentation only: CATALOGUE NOS. 1–3, 11, 14, 16, 19, 21–23, 28.

PUBLISHED BY

Los Angeles County Museum of Art
5905 Wilshire Boulevard
Los Angeles, California 90036

AVAILABLE THROUGH

D.A.P./Distributed Art Publishers
636 Broadway, 12th floor
New York, New York 10012
Tel: (212) 473-5119 Fax: (212) 673-2887

Edited by Mitch Tuchman
Designed by Jim Drobka
Photography supervised by Peter Brenner
Text composed in Kaatskill, designed by F. W. Goudy
Display types include Rosewood, Quentin, and Grotesque.
Printed by Monarch Litho Inc., Montebello, California

Note to the reader

Titles, particularly of individual works included within series, which may have been published elsewhere in modified format or with variant capitalization, have been standardized here by agreement with the artist.

Photography credits

Peter Brenner: CATALOGUE NOS. 1, 3–11, 13, 25, PAGE 64
Douglas Parker Studio: CATALOGUE NOS. 2, 14–21, 23–24, 26–31, 33, 35
Gene Ogami: CATALOGUE NO. 12
Oren Slor: CATALOGUE NOS. 22, 32, 34
PAGE 68: Copyright 1983 by Smithsonian Institution
PAGE 72: Fotostudio Otto, Vienna

Library of Congress Catalog Card Number: 95-081977
ISBN: 0-87587-177-1

Contents

Foreword

ANDREA L. RICH
President and Chief Executive Officer
Los Angeles County Museum of Art

This is the first comprehensive survey of paintings by Lari Pittman, a Los Angeles artist believed by many to be one of the most significant American painters today. Since his first solo exhibition, in Los Angeles in 1982, his art has been widely exhibited in the United States and Europe. However, the public has seen his work for the most part only in periodic exhibitions, and the critical response, while almost universally favorable, has been largely limited to reviews. In this mid-career retrospective exhibition the Los Angeles County Museum of Art brings together Pittman's most ambitious and seminal works to offer an overview of his stylistic and thematic development.

Pittman himself has remarked that his art is "an acquired taste," and it is true that it can be daunting at first sight. Like most fine art, however, it persists in its appeal to the senses, the emotions, and the intellect. Through his spectacular imagery and exuberant decorative style, Pittman explores issues of individual identity, often from a gay perspective. Beyond that, he celebrates the idealism of American culture, and he upholds a traditional belief in the capacity of art to reveal transcendent truth to the beholder. Pittman presents this rich offering in a body of art that is remarkable in its effusive spirit.

Through its collections, exhibitions, and publications the Los Angeles County of Museum of Art has always striven to reflect the vitality of contemporary art in Southern California. As Los Angeles becomes more and more cosmopolitan and its art community increasingly influential in the global art world, the museum's role in the presentation of contemporary art that is created here is more crucial than ever, and it will remain so. We are proud to offer this exhibition and its publication.

Joyful Noise

The Art of Lari Pittman

HOWARD N. FOX

Since the early 1980s, when he began producing and showing some remarkably venturesome works, Lari Pittman has emerged as one of the most engrossing American painters of his generation. Working consistently and diligently, he has built a succession of bold, painterly experiments that combine abstract and representational modes in audacious ways into a unique stylistic vocabulary and a sustained body of mature, visionary art. The work has evolved as something of a spiritual odyssey and a running commentary on his own life and on American society and cultural attitudes. Sometimes it has reflected periods of acute despair and a recognition of the foibles and woes intrinsic to human behavior; mostly, however, his art stands as a joyous affirmation of life. Indeed, the idealism central to the humanist tradition in Western civilization which aspires to transcendence through love, beauty, and art is central to Pittman's own art, and he extols these traditional values in a startlingly original art form whose meanings are ultimately emotional, political, and philosophical.

With their baroquely decorative surfaces, cartoony images, and an iconography that is at once rooted in popular culture yet intensely personalized in meaning, Pittman's paintings are always exhilarating—but often baffling—to behold. His works are so visually complex that at first glance they can seem nonsensical. His peculiarly arresting juxtapositions of apparently unrelated images, blurts of exclamatory text, and broad expanses of runaway decoration, all gleefully rendered in riotous colors, can certainly leave viewers wondering what it all adds up to—or even if it means anything at all. Pittman has always known this and readily admits that "the work can look shallow. It runs the risk of being read as 'Lari-Lite.'" [1]

As if to prove him right, even his most admiring reviewers regularly pepper their descriptions of his art with such arch phrases as "inventive"; "curious"; "personal"; "highly personal…private and uniquely personal"; "whimsical…daffy"; "bizarre"; "peculiar…mixed-up". [2] They not only assert that his work is strange in general, they hint that it may be anomalous even within the rambunctious art world, politely typifying his endeavor as "revisionist"; "difficult to pin down… cranky—willfully eccentric"; "intentionally murky territory"; "runs directly against the current trend"; "composed from a visual language whose syntax you don't yet recognize"; and "confounds categories…art world aberrations." [3]

While each of these characterizations was put forth laudingly—the published commentary has been all but universal in praising Pittman's art— there can be no doubt that the critical consensus is that his art plays by its own rules, is somehow marginal and outside the norm: outré, other, queer. Pittman himself acknowledges that his art is "an acquired taste" and allows his own observation that "I think the work is fruity."

1

All quotations of the artist are from conversations and tape-recorded interviews with the author in the preparation of this volume. Some comments have been lightly edited for grammar or continuity but in a manner that has not altered the intent or viewpoints of the artist.

2

"Inventive": Christopher Knight, *Lari Pittman Paintings* [*LAX*] 1992, exh. cat. (Vienna: Galerie Krinzinger, 1992), unpag.; "curious": Robert L. Pincus, "Pittman as Bright as Ever," *San Diego Union-Tribune*, 28 November 1993, E-5.; "personal": Fred Fehlau, "Lari Pittman: A Close Reading," *Visions* 3 (winter 1988): 18; "highly personal…private and uniquely personal": Colin Gardner, "Lari Pittman," *Flash Art*, no. 120 (January 1985): 46, 47; "whimsical…daffy": Donald Britton, "Cover: Lari Pittman," *Art Issues*, no. 11 (May 1990): 36; "bizarre": Alisa Tager, "Lari Pittman," *Tema Celeste* (January-March 1992): 119; "peculiar…mixed-up": Benjamin Weissman, "Lari Pittman," *Art Issues*, no. 4 (May 1989): 25.

3

"Revisionist": Susan Kandel, "Lari Pittman," *Arts Magazine* 63 (April 1989): 109; "difficult to pin down…cranky—willfully eccentric": Tom Knechtel, "A Wistful Angst," *Artweek*, 22 January 1983, 7; "intentionally murky territory": Susan C. Larsen, "Lari Pittman," *Artforum* 21 (May 1983): 104; "runs directly against the current trend": Marc Selwyn, "Lari Pittman," *Flash Art* no. 152 (May–June 1990): 158; "composed from a visual language whose syntax you don't yet recognize": Christopher Knight, "Pittman Paints in His Own Language," *Los Angeles Herald Examiner* (27 January 1989), Weekend, 7; "confounds categories…art world aberrations": David Pagel, "Art Reviews: A Thrill a Minute," *Los Angeles Times*, 7 November 1991, F-7.

Yet for all their brass and sass, Pittman's hyperactive tableaux are slow takes, needy of, insistent upon, and finally rewarding to patient exploration and open-minded discovery. Fact is, the glut of color, the loopy decorations, and the zany images that romp through his art, visually overwhelming the viewer at first glance, are purposefully calculated to unfold gradually in the viewer's imagination and disclose a deeper significance. The artist justly bristles at the notion that his project is simply idiosyncratic, eccentric for the sake of being so. "It's not about marginalization, it's not a freak show," he asserts, declaring that his art "is perhaps as central as anything else" in contemporary culture. "It's always too easy to say, 'Oh, it's about eccentricity.' No, it's about identity."

Identities, plural, might be more apt. "Purity of identity has always bothered me," admonishes Pittman; "I hate essentialism." Speaking of himself, he comments that "I have a very hybrid identity," pointing out that his mother was Colombian of Spanish and Italian descent and a Catholic, while his father was of German and English parentage and a Presbyterian by upbringing, who very decidedly broke away from his family's "staunch kind of unbending, nondrinking Protestantism." Pittman was born in 1952 at Glendale Memorial Hospital near Los Angeles, but he spent most of his childhood in Cali and Tumaco, Colombia, where his father was in the lumber industry, before returning to the Los Angeles area at age eleven, in 1963. He credits this unusually rich mix of divergent national, ethnic, religious, and cultural sensibilities as well as his identity as a gay person and also the experience of living in Los Angeles with instilling in his art at least some of its visual zest and commotion. It is not surprising then that Pittman has said, "I think of myself as a realist painter in the sense that I try to use the juxtaposition of imagery in my work to mirror the incredible mixture of cultures and habits,"[4] not only of his personal background or daily life in Los Angeles but of American urban culture in general at the end of the twentieth century. It is a vital, yet agitated world that he reveals, a universe that teems with the unruly activity of living, with old and new truths, with unfathomable dreams and mysteries.

Of course, Pittman is not a realist painter, nor is his art fundamentally, or even primarily, autobiographical. Rather, the identity that Pittman reveals and celebrates, again and again in his art, may be described as a kind of collective cultural identity, the spirit of American popular culture in an era when once-abiding ideals are confronted by new realities. The theatricalized stick figures, silhouettes, and cartoonish characters that have populated Pittman's decorated tableaux for the past decade are intended to stand less for himself than for all of us. In this, Pittman's art has affinities with the poetry of Walt Whitman, especially *Song of Myself*, the epic, rambling, incantory portrait of America sung, not by the historical Mr. Whitman, but by a persona that aspired to represent the experiences and aspirations of all. Similarly, the narrator or persona in Pittman's art is not Mr. Pittman, but one who has truths to tell. The Puritans, lovers, villains, and dreamers in Pittman's art are generic and might stand for any of us; collectively they act out a kind of latter-day morality play through which the artist expresses, with unabashed sentiment, traditional values and ideals about freedom, self-determination, love, and community.

There is a multitude of touch points and entryways into these grand themes that pervade Pittman's art, none any more correct or fundamental than another. He composes each work as a dense web of interconnections, overlays, and interlockings that resonate both visually and conceptually. Instead of arranging his images conventionally around a central focus, Pittman works expansively, sending essential elements coursing laterally across the surface or ringing the perimeter or sprawling in dazzling array all over, while connecting the disparate elements with busy frameworks of lines, filaments, patches of color or texture, or decorative patterns. So multifaceted is the surface of a typical Pittman work that it appears to be constantly shifting and reinventing its image field and cannot be read all at once. Indeed, the artist makes the viewer do a little work to put the images together bit by bit, like an elaborated follow-the-dots game, in order to divine some signification in it all. But Pittman liberally seeds each opus with access points, and virtually any element, whether formal or iconographic, offers a path into the inner meaning of the art.

No aspect of Pittman's art is more obvious or ubiquitous than the rampant decorations that make it so formally ravishing, so...*beautiful*; indeed, it is through this dazzling optical allure—this "frippery," as the artist calls it—that his art first exerts its presence. In his conception, however, decoration is not simply some frill, like architectural gingerbread, tacked on. For Pittman, decoration can be truly *beauty*-ful and is indivisible from the emotional, intellectual, and philosophical meanings of his art. That equation itself probably had its last general currency in the high romantic age and may have its pithiest expression in John Keats's odic declaration: " 'Beauty is truth, truth beauty,'—that is all / Ye know on earth, and all ye need to know." It is a notion not widely shared in the modern age.

While the concept of beauty has not been totally excluded from the modernist canon, it definitely did come under extreme critical scrutiny, and it surely has come to be severed, theoretically, from ideas about decoration and the decorative mode. The example of Henri Matisse—decorative artist *extraordinaire*—notwithstanding, in the generally reductivist, puristic tendencies that forged modernism's most revolutionary thrust, one faction after another endeavored to distill art into what its adherents saw as art's truest, most essential nature; and in their viewpoints, decoration (usually defined as adornment or ornamentation) was broadly derided as an archaism, a once-acceptable artistic indulgence that succeeded mainly in prettifying the banal and eclipsing (if not altogether supplanting) the inner or essential nature of "real" art. The attitude is neatly summed up by the abstract painter Hans Hofmann, an influential mentor to a generation of abstract painters, whose essay "The Search for the Real in the Visual Arts" is a classic article of modernist faith in exactly what its title says:

There are two fundamentally different ways of regarding a medium of expression: one is based on taste only—an approach in which the external physical elements of expression are merely pleasingly arranged. This way results in decoration with no spiritual reaction. Arrangement is not art. The second way is based on the artist's power of empathy, to feel the intrinsic qualities of the medium of expression. Through these qualities the medium comes to life and varies plastically as an idea develops.

The whole field of commercial art and much that comes under the heading of applied art is handled in the first way and is chiefly decorative arrangement. The so called fine arts are handled in the second way to give the total of man's inner self—his spiritual world which he can offer only as an artist in the most profound sense.[5] For Hofmann and the overwhelming majority of modernists the decorative mode was clearly a suspect attribute. Not only degraded from its traditionally respected role, decoration had come to be viewed in the twentieth century as a debased concept, an artistic indulgence whose very capacity to express anything of emotional or spiritual depth was specious at best.

For Lari Pittman the decorative mode holds untold depth as well as utter fascination. A significant aspect of his artistic maturity was confronting the issue of the debased status of decoration. He knew that indeed there is such a thing as *merely* decorative art; but he also knew from personal experience that decoration could arouse great aesthetic pleasure in itself and also express what Hofmann described as "man's inner self—his spiritual world." "What struck me," Pittman recalls, "was why should surface embellishment be declassified or culturally regarded as lesser? Decoration alone is not enough; the world is full of that. But what an odd combination: surface embellishment *and* meaning. I felt the need to fuse them together."[6]

Apparently his impulse to fuse decorative form and extraformal content is deep-seated in his early psychological development, and he seems, in retrospect, always to have associated decoration with festivity and exaltation. This is clear in his recollection of a family anecdote that was repeated often and with tremendous delight and one that he frequently tells at

4

Lari Pittman quoted by Holland Cotter in "Eight Artists Interviewed," *Art in America* 75 (May 1987): 169.

5

Hans Hofmann, "The Search for the Real in the Visual Arts," in *Search for the Real and Other Essays*, ed. Sara T. Weeks and Bartlett H. Hayes Jr. (Cambridge: M.I.T. Press, 1967), 46.

6

Lari Pittman quoted by Christopher Knight in "L.A. Art Star Has a Stroke of Ingenious Reinvention," *Los Angeles Herald Examiner*, 22 February 1987, E-6.

the start of slide lectures about his art. Lari and his brother Oscar hatched a plan to celebrate Father's Day by making a special breakfast for the family. Oscar, being older, would do the cooking. To Lari fell the responsibility of setting the table. "I was about four. I remember very, very clearly that I set the table. Then, as a child, I thought, 'OK, this is something. We're doing something special.' And in my instinct, or however it came about, I took all my mother's jewelry, and around each of the plates I put necklaces, and I remember clipping clip earrings to the top of each plate. I guess it must have registered to me, 'OK, we're doing something significant and meaningful'; but then I could fix up that meaning by decorating it."

Clearly in the youngster's imagination the meaningfulness of the festivity called for and was enhanced— was honored, so to speak—by its embellishment with something that he understood to be visually beautiful and aesthetically stirring. The ornamentation, naive and winsome, served to heighten the participants' awareness of a notable event; the gesture of visually "dressing" the setting was worthy, decorous, appropriate to distinguishing the occasion. "I think very early on the whole idea of decoration-*and*-meaning probably became very cemented and not split apart."

And so it remains today. For Pittman decoration has less to do with adornment—the addition of some extraneous embellishment to the object or event of interest—than it does with the acknowledgment and clarification of the focus of interest. In Pittman's art decoration functions rather like the mask in a Greek drama, not to conceal or divert attention from the focus but to magnify and project it for all to see. He does not set up decoys or diversions. Pittman uses decoration expressively, even expressionistically, to reveal human emotions, desires, dreams.

The decorativeness of Pittman's art has complex psychological and cultural implications as well. The decorative impulse is related in his psyche to gender roles, to his own homosexuality, and to the self's relationship to society, which is expressed through his art. Once again Pittman's childhood memories evoke antecedents for his art today. He observes that while other boys might have been scolded

for playing with their mother's jewelry or gussying-up the dining room, "another child's trauma was my praise. And as a male child [I] was just absolutely praised, and that impulse was never, never a problem." At least not at home, where his parents and his aunts accorded him a special status as "the sissy child." Pittman recounts that he was "very effeminate—very prissy, very precocious, and always very vain....When I was very little I would comb my hair with butter," and he insisted on his clothes always being perfectly ironed. "I did not want to wear long pants until it was 'too late.' I always wore short pants, and then as a child my knees would get scuffed up, and I used to scrub my knees with Ajax." He adds, "These are just foibles. But I think they mean something, you know."

Indeed. What these foibles seem to suggest today is that during Pittman's formative years, notions of decoration may have held for him some association with specialness, celebration, and idealization. His early preoccupation with decorating, presenting, and ordering things visually now appears to have been an incipient expression that would later emerge as a fundamental element of his adult art. But if his impulse to decorate and to exalt had been accorded "special status" at home during his childhood, it was not to be later in life.

The allegedly rambunctious art world, for all its fads, fashions, politics, and hucksterism, can be a crushingly academic and doctrinaire place, lavishing abundant critical attention on one set of creative issues while all but missing, or dismissing, another. As an undergraduate, first at the University of California, Los Angeles (1970—73), and later at California Institute of the Arts in Valencia (1973—76), his penchant for the decorative was viewed suspiciously and perhaps prejudicially, given the sexual politics of the era. "At that time, the rhetoric around women's art was that it [decoration, the decorative impulse] was information privy to women, exclusive territory. So they didn't quite know what to do with me. I found much of the feminist discussion around that topic to be inhibiting,

though, because to put a certain pedigree to a function in art-making disturbed me. It seemed gender-confining."[7] Pittman acknowledges that "I was not immune to that discussion" or to the critique of issues of authorship and personal expression that were also current, and "I felt very awkward at times."

At the same time that some of his principal formal interests appeared to be politically off-limits to him, during those early years following the heyday of minimalism and its profoundly reductive strategies, the art form of painting itself was viewed by many of his contemporaries as if it were "a picked-clean carcass." As if the critical discredit of his chosen art form were not obstacle enough, some influential faculty members at CalArts actively discouraged their students from the pursuit of painting, which they found to be anachronistic and divorced from developments in the new hybrid, intermedia art forms (such as site-specific installations or performance art) that were laying such claim upon the imaginations of many artists at that time. Beyond the art-world quandary over the surmised death of painting, the content that was rapidly becoming of the deepest meaning to him personally and artistically—visual beauty, themes of love, and a dedicated idealism that inspired him in the first place—were derided or shunned altogether. What Pittman wryly (and self-mockingly) calls "these issues of high romance and high perfume"[8] simply were not dealt with in the art polemics of the time.

Although Pittman stayed in academia for six years, earning both a bachelor's and a master's degree in fine arts (and is today a tenured faculty member at UCLA), he always found the proscriptions and shibboleths of the academic art world to be quite confining and not a little demeaning. Throughout his student years he could not escape the feeling that his work was being regarded as marginal to the controlling art issues and artspeak of the day. Perhaps his art's dislocation from—or inaccessibility to—the academic mainstream was partly his own doing. Throughout the 1970s and into the early eighties, Pittman's painting, brash as it appeared formally, was somewhat evasive or tentative in terms of

its inner subject matter. Within many of his intrepid experiments in combining abstraction and representation, it is possible to discern a narrative, but one so veiled and unintelligible that it can only be described as covert and very nearly suppressed altogether.

*F*rom *Venom to Serum* (1982; **CATALOGUE 2**) is typical of Pittman's work from the early 1980s. Colorful grids, decorative curlicues, and painterly textures punctuate the painting's surface. The painting is divided into two discreet sections: a narrow field of red on the left; an expansive, murky field to its right. A large curvilinear, black shape in the murky area is highlighted by a radiant aura that prompts the viewer to "read" the shape as the picture of an object, one that happens to pierce the boundary between the two fields. Each field is inhabited by a vague, humanoid figure. The "person" in the red area is formed by two ovoid shapes that roughly delineate a head and torso, while the figure in the murk is formed by a swatch of printed fabric (appropriated from a manufacturer's sample book), perched above two liney "legs," and looks like a blocky headed stick figure.

The visual "narrative," vague though it is, describes in the most generic way a barrier crossed, a separation transcended, a person-to-person connection. The painting functions less as a story with a plot than as an implied narrative that operates on a dim, subliminal level. In conversation Pittman says that in his mind the black shape represents "a distillery, like a moonshine still," in which one substance is converted into another. While this specific item of information is not available to the viewer, the painting's title—and Pittman's titles always offer significant clues and information about his works' import—*From Venom to Serum*, does suggest that in the scenario depicted by the painting, something venomous—perhaps a poisonous substance or a malicious emotion—is converted to serum—something tonic, immunizing, or remedial. It describes a

7
Lari Pittman quoted in ibid.
8
From a lecture by the artist at the Armand Hammer Museum of Art and Cultural Center, Los Angeles, 20 August 1994.

healing process in which something perilous or bad is transformed into something curative and good. Indeed, Pittman has said that he regards this early work as "the acknowledgment of a simultaneity, that what can kill can also be the potion for healing."

Such heady ideas, though, are scarcely retrievable from this strange and curious painting itself. If Pittman's art of the 1970s and early eighties was in any way consigned to the margins of the art discourse of the moment, it must also be acknowledged that his paintings at that moment were perplexingly—almost unnecessarily—obscure. In light of what was soon to come, it appears in retrospect that many of the young artist's early works, audacious as they were formally, were somehow holding back, concealing information rather than broadcasting it. Pittman himself describes his art of this period as "very arch, very mannered, and speaking in code." Rather than speaking forthrightly, the early works seem to grope for analogies, alluding vaguely to some sort of dualistic world, an inchoate territory of simultaneous realities with navigations and transformations from one condition to another.

Why such obliquity? It might seem a plausible explanation to surmise that by his hinting at, yet never quite revealing, a deeper level of content in his work and by "speaking in code," Pittman was using visual, formal, and cultural cues to reflect some deep but important secret, possibly a double life, maybe the hidden identity of a closet homosexual. However, that humiliating cliché is not true for Pittman or for many gay people who came of age after what is often called the "sexual revolution" of the 1960s. Pittman never experienced a crisis in coming to terms with his homosexuality, and he has been openly gay all of his adult life, living with his companion, the artist Roy Dowell, for over twenty years. If Pittman was harboring or furtively hinting at anything, it was an indulgent sentimentality, an inspired idealism, and deeply romantic values, for which he risked being truly marginalized and ridiculed in an art historical period that was extremely skeptical, if not utterly cynical, toward many of the values he knew inwardly that he believed in. It may or may not have been prudent of him to be chary of the art world's critical

response to unfashionable ideas, but Pittman's reticence seems to have temporarily occluded the more urgent content waiting to flourish in his art. Sooner or later something had to give.

One night in 1985 a catalytic event happened that dramatically changed Pittman's life, his outlook, and ultimately his art. Awakened by the sounds of a burglar attempting to break into the house, Pittman jumped out of bed, ran to the window, and tried to frighten the intruder away. Instead of running, the robber shot Pittman, nearly killing him. Emergency room surgeons were able to save him and to more or less reconstruct his innards; other restorative surgeries followed over a period of years. During the lengthy recuperation that followed the shooting, Pittman, depressed and chronically fatigued, ceased painting and would not resume working, even after he had recovered enough physical strength to return to the studio.

It was Dowell who helped Pittman resume painting, literally putting a paintbrush into his hand and insisting that he get back to work. Reluctantly, but inevitably, Pittman did. Not surprisingly, his paintings at that juncture were morose, filled with images of ruin and desolation. But over a period of nearly three soul-searching months, as he came more and more to consider that he had, in fact, survived the ordeal rather than perished in it, his vitality and return to creative life became immeasurably more meaningful to him than what had been his ravaging plight. Being an artist was more important than being a victim. That emphatic realization provided the stimulus for him to return to his painting with a renewed sense of affirmation. And it may also have inspired the evolution of his mature art into an exultation of human existence.

Pittman's early work was, by contrast to the work after he was shot, hermetic. "That's the word I would use: it was more hermetic. It was a little bit more of a conversation between me and the work." Later, when he finally resumed working, his motivation as a painter had a new focus and enhanced purpose: "Clearly an event like that opens up a

bigger picture of larger implications of exactly what it is that we're doing. The later work functions, I hope, as a conversation between me and the world." Pittman views engaging in this larger conversation, beyond the object per se, as the maturing of his art. "I think that work becomes, or can start becoming, mature when it disengages exclusively from that binary conversation between the artist and the work."

Thinking back on the affair, Pittman reflects that "it had profound repercussions on all sorts of levels…. That brush with death made me tense in many ways, but it also made me relax about using my work as a vehicle to discuss responsibly that this is the way Lari looks at the world—or at worlds. That incident [the shooting] reorganized things very quickly."

It took great independence and courage to set aside the orthodoxies and prejudices of the prevailing critical discourse of the day, especially in making art that sprang from his own sentimentality and longing idealism; but he was finally able to say, "Oh, what the hell! I don't care anymore. *Let* it be gushy. *Let* it be highly romantic. *Let* it signal a mature male pining away. I relaxed knowing that life is very tenuous."

Pittman's previous evasiveness about being openly "gushy," "romantic," "pining away," and gay in his most public form of expression, his art, gave way to an affirmative demeanor of self-determination. Neither the parochialism of the art world toward his artistic values nor the fears and suspicions of some segments of American society toward homosexuality would deter him from a good-faith airing of his views. Among the very first works he created after he put the worst of his despair and anger behind him were a group of six painted gourds (1985; CATALOGUE 5-10), each one titled after a virtue: charity, compassion, forgiveness, faith, hope, and kindness. To make such oddly presented paintings—the painted shells of fruits, actually—and sincerely dedicating them to virtues was a gesture that risked being ridiculed as maudlin or quaint or—even worse—saccharine. If Pittman gave much thought to the risk, clearly he wasn't bothered by it. Those very virtues, those healthful states of mind, helped him overcome his

despair and anger in the months after the shooting, and it was more important to him personally and professionally to acknowledge that in his art than to camouflage it.

Another group of works that issued from this new-found sense of mission—to present responsibly the artist's true vision of the world or worlds—constitutes something of a personal declaration of independence from what might be seen as a tyranny of essentialism—a doctrinaire conformity to certain conventional attitudes, mores, standards, and behavior that are deemed essential to the identity of a society or culture and which are imposed on all its members with the presumption that such conventions are inherently functional, beneficial, and true for all. A group of energetic paintings begun in 1985 and bearing such titles as *Plymouth Rock 1620*, *The New Republic*, *Thanksgiving*, and *An American Place* reflects his interest in the roots of American values, especially in their echo of a distinctly American belief in the promise of new beginnings and the flourishing of ideals when they are freed from the yoke of an imposed political order and moral taboos. Now Pittman is no blind fool about the extent of American liberties or how they were conceived, and delimited, by our society's Puritan forebears; and these paintings, for all their freewheeling, improvisational appearance, are highly organized in terms of content and not without some pointed irony about traditionally American, puritanical attitudes toward the body and sexuality. Pittman asserts his independence, not from American ideals, but from the blind or untested belief in any ideology.

In *Thanksgiving* (1985; CATALOGUE 13), for example, an arrangement of gourdlike forms radiating like a starburst from the center of the painting is penetrated by a very plainly delineated phallic form. The gourd—a symbol of virtue to Pittman and in the context of the American Thanksgiving celebration, a symbol of both vegetal bounty and divine providence—is juxtaposed with the most obvious signifier of male sexuality and in a manner that in no way restricts its reading to one of procreation. One reading of the painting suggests a crude violation, a rape, and this may well reflect the anger and upset that Pittman still was coping with after the shooting; but as with all of his art

this painting is too complex to rest with a single interpretation. There is also a strong undercurrent of hope and affirmation in *Thanksgiving*. As if to underscore his own recognition of sexuality as an integral, *virtuous* part of the lives of *all* men, and *all* women—who, *all* Americans know, are created equal—Pittman explicates the composition with the words, writ large, "life," "liberty," and "pursuit of happiness." The cardinal American ideal of free, responsible self-determination, he implies, must extend to certain issues of sexuality, including homosexuality. Perhaps the phallic penetration depicted in the painting is not a rape so much as it is a loss of innocence—but a loss ultimately to be thankful for. In a true and healthy spirit of American resistance to accepting, unquestioned, the veracity of the mores and moral dictates that we inherit as members of a culture, Pittman affirms his faith in the ability of individuals to discern self-evident truths and to uphold the ideals they believe in, even in a world that undermines or assaults them at all turns.

Nowhere is Pittman's idealism more assertive than in a series of utopian works from 1987 and 1988 which falls somewhere between a languid "pining away for a better world" and the purposeful testament of an inner and deeply committed idealism. These works of dizzying iconographic complexity mark a significant formal breakthrough in Pittman's oeuvre, introducing a new illustrative quality. Their images, not nearly so abstract as in earlier works, include cartoonlike representations of mountains, oceans, boats, bridges, plants, animals, body parts, and so on, while the number and dynamic quality of decorative curlicues, spandrels, patterns, and arabesques are stepped up to fever pitch. The series features the constantly recurring motif of a grand sailing ship embarked on a fantastical voyage to some transcendent realm that exists nowhere in present time or space. The dreamy landscapes are surrounded and crisscrossed with decorative elements, which function rather like the mosaic of spectral colors in stained-glass windows of Gothic cathedrals, to amplify the spiritual or

metaphysical content with ecstatic visual display. For Pittman these decorative elements have something to do with "the whole idea of a gay aesthetic," a concept that he does not attempt to define but says he associates with the idea of "'drop-dead-beautiful.' Like when something is so beautiful it's beatific. The word *beatific* means you've seen God, and that you can drop dead then at that point." Pittman is no mystic or seer or dreamer, but he does embrace the romantic idea that the experience of beauty is ecstatic and enables the perception of truths that transcend the here and now.

It is not only the visual content of Pittman's paintings that describes a place out of space and time, it is also their wistful titles—such as *Where the Soul Will Replace the Body in Importance* (3210 A.D.), *Where Suffering and Redemption Will Sprout from the Same Vine* (7344 A.D.), and *Where the Soul Intact Will Shed Its Scabs* (8624 A.D.)—that describe no place or time yet inhabited by humankind, except in our imaginations. In fact, the images and titles evoke not so much an imaginary place or time as they do a state of mind: a deliverance—a beatification or an exaltation (albeit an altogether secular one)—into a state of moral goodness and spiritual well-being. There is an undeniable fantastical element to this series; yet to think of the works as mere fantasies or idle daydreams would imply that they are deviations from what we call real or realizable and would undercut the serious and thoughtful nature of these works. They are far closer to being visionary assertions of a truly held idealism than they are eccentric escapes into make-believe. What the artist pays homage to in this series—respect, loyalty, generosity, honesty, enlightenment, love—are nothing more, and nothing less, than some of the most venerated virtues in our civilization, and they represent the ideals by which we judge ourselves and one another as well as what we teach our children as the values to which they must aspire.

The series underscores Pittman's belief in or desire for a world of human intercourse that is, if not perfect, more nearly informed by the higher truths we love and honor, or at least profess to. That Pittman displaces his voyage into the far distant future only serves to emphasize his canny

understanding of the way of the world and human nature: no world order that he describes is likely to come true in real time, that is, in our lifetime. Yet his creation of these works is a very real act of faith in the capacity of art to reveal higher truth and in the imagination of the viewer to behold it. Even if Pittman's setting the voyage in an only dreamt-of time suggests a despondent "pining away," his undertaking of series in the first place is essentially a moral act embodying his tacit insistence that the ideals and sentiments celebrated in the dream ought to have—indeed must have—voice and expressive form in life and in art.

There is one aspect of Pittman's art about which there is no anxiety or ambivalence, a human aspiration that he extols in its perfect ideality. It is love. He celebrates love wherever and for whomever it flourishes, whether it is gay or straight. Though Pittman recognizes the necessity to remain vigilant, even combative, in asserting the moral and civil rights of homosexuals and to decry the gay bashing that occurs regularly in American society, that need is strictly a social problem. Pittman does not question or doubt that homosexual love is as humanizing and virtuous and ennobling as heterosexual love. For him it is not an issue. Regardless of what some religious denominations or political factions may profess about homosexuality and love, Pittman presents them as emotionally and morally equivalent to heterosexuality and love and respectful of many of the same values.

A series of pictures painted during 1989 and 1990 exploring aspects of love includes some of the most inspired, positive, and confident works in Pittman's oeuvre. Each painting bears a title that begins with a phrase describing an attribute of love, such as "this desire," "this amusement," or "this wholesomeness," and is completed by the phrases "beloved and despised, continues regardless." Each painting depicts a busy microcosm of Victorian ladies, gentlemen, and children involved in the activities of living: working, creating, socializing, making love, and even dying. Integral to each painting is an image of physical and

emotional union, usually—but not exclusively—homosexual. It is the homosexuality, beloved by some and despised by others, that continues, inevitably and naturally, regardless of any moral or political judgment about it. The formal organization of these works is typical of Pittman's established all-over approach, but their visual complexity is counterpointed and ordered and unified by the simplicity of the image of love.

The centerpiece of the series may be *This Wholesomeness, Beloved and Despised, Continues Regardless* (1989; CATALOGUE **26**). This painting, like many of Pittman's works, has an implied narrative structure and is divided into two sections: a bright yellow lower portion that Pittman says is "daytime" and an upper grayish-green area that represents "nighttime." "These two men meet," he continues, "and they're very clearly attracted to each other. They're sexually aroused by each other. There's a bridge between them, a metaphorical bridge that they'll walk on and meet each other. By evening they've met, and they're making love, reaching some kind of wonderful fruition and communication, on the banks of a river. And while they're making love, the bridge is used by other pedestrians for their social function also. So the lovers' desire is completely wholesome and part of a larger picture. And then there's this bell tower that's just proclaiming it." The couple's healthful, virtuous act of living and loving enjoys the blessing and social sanction of a virtual marriage, replete with the community's participation and celebratory pealing of bells. This whole nurturing scene is presented as a tableau, with a curtain pulled grandly aside to reveal the story. It is the *theatrum mundi*, the theater of the world. "It's almost like an opera," Pittman declares, describing how in the finale, after trial and tribulation, the chorus sings rousingly about happiness and liberation.

The united lovers, whose hearts, brains, and groins are aglow in fiery red, are surrounded by a set of concentric circles that recalls the cosmological charts and maps that appear in many medieval and early Renaissance paintings; but at the top of this cosmology, and announced in a starburst, is the number 69. Surely there is no American over the age of puberty who does not recognize the winking

significance of the number 69, defined in the dictionary as a slang term denoting "simultaneous oral-genital sexual activity between two partners." Now the subject of oral sex—today freely discussed on mainstream talk shows and even in polite conversation—is hardly the taboo it may have been in previous generations; and Pittman's invoking it is anything but a cheeky affront to respectable manners. In his art the number 69 is used virtually as an icon: "This is the number of union," he says. "It's not so much about the physical act as it is about a symbiosis," a mutual giving and receiving, an interdependence and fulfillment that occurs in love. The sly number here denotes no mere sexual act but rather connotes the consummation of that physical, emotional, and intellectual union that is love itself.

Other paintings in the series, if not quite so rhapsodic in mood, are equally affirming of transcendent emotion and imagination. For example, in *This Desire, Beloved and Despised, Continues Regardless* (1989; CATALOGUE **23**), the composition is divided into a foreground and a background. In the distance is a sterile, foreboding tower that appears to be ironclad, as if it were a prison, yet the prison house is connected by a tightrope and a bridge to another, quite phallic, very brightly colored tower in the foreground; this closer tower is depicted as an apartment building, with balconies and windows open to reveal the activities of life in all their wonder and banality. Among the actors are a little girl with a flower, a dead woman, a young woman, two men meeting on a balcony, an old man, an old woman spitting, two men making love, a little girl with her doll, a woman arranging flowers, a man painting. These activities are vivid or humdrum according to the imaginations of those who experience them. In a politely comic touch, in the right foreground a woman sits in a chair weeping grandly. A second glance discloses the cause of her profuse tears: she is paring onions. Pittman implies that in life the appearance of high drama may mask something absolutely trivial; while something as commonplace as making love may so exalt an individual's life as to all but beatify it.

This painting suggests that desire—and its denial or fulfillment—is the very substance of life and the significance it holds for the individual. Desire might embrace

anything; but ultimately it is states of mind—not necessarily life-and-death events—that fulfill or deprive a lifetime of its meaningfulness. There is great richness often to be found in the ordinary and often nothing much to redeem what appears to be extravagantly affecting. It is the will and the wisdom to discern meaningfulness, freely and for one's self, that establishes identity and what one derives from life. For Pittman consciousness itself is, like art, constructed and decorated as an act of imaginative response. "Everything has to be willfully constructed," Pittman comments. "You construct love. You have to constantly create meaning. You can make a life, you know." Significantly Pittman identifies the protagonist in *This Desire…* as the youthful figure crossing the tightrope from the prison tower over to daily life. His passage is an act of self-determination.

For Pittman there is always a gap to be bridged between the real and the ideal, and art (like religion, philosophy, or love) can be that connection. Art, it must be acknowledged, can also be informed by concepts and phenomena that have absolutely nothing whatever to do with anybody's ideals or philosophy, but Lari Pittman has chosen to affirm a transcendental function in his own art. He elects to credit (his) art with the capacity to inspire an awareness of things we cannot know empirically (that is, the literal facts and conditions of the here and now that we can perceive through our senses) but that we can only imagine or meditate on. *This Landscape, Beloved and Despised, Continues Regardless* (1989; CATALOGUE **24**) is a meditation on the power of art to embody and perpetuate ideals. It is loosely based on a painting titled *Wanderer above a Sea of Fog* (1818) by the German romantic painter Caspar David Friedrich (1774–1840). Like other European and American romantic landscapes, Pittman's depicts not only a vast terrain but also an artist painting it; in a sense this is a painting about painting.

Pittman's protagonist stands on a precipice overlooking the sea and a distant mountain. Like other figures in the Beloved and Despised series, this gentleman, decked out in nineteenth-century finery, is something of a dandy, and Pittman surrounds him with twinkling stars and flowers. He is also surrounded, at least below ground, by legions of the dead—men, women, and children, supine in their

coffins; the sea is aswarm with extravagantly finny sharks and sea beasts, and the presence of danger is signaled by bright red buoys; even in the upper portion of the composition, which is dominated by the artist, the landscape itself forms the shape of a skull. In fact, there is death and danger all round. Yet the artist, blithely ignorant of or foolishly indifferent to what lurks so close, keeps painting away, looking not down to death and destruction but outward to the stars. With gentle, comic irony, but without cynicism, Pittman sets his protagonist in a world that is suffused with and even contained within death. Realistically speaking, doom is certain for the artist, just as it is for everybody else. Pittman, however, intends this painting less as a memento mori than as a paean to art. By choice or by foible, Pittman's artist is satisfied to revel in his enchantment at the majesty and awe of nature sublime; and his art, like his idealism, continues regardless.

Late in 1992 Pittman began an amazing series of paintings, which continued into 1995, titled *A Decorated Chronology of Insistence and Resignation*. These frenzied, visionary paintings are unique in the history of modern American art, and they rank in ambition and originality with such visionary creations as the allegorical quartet The Voyage of Life (1839–40) by Thomas Cole (1801–48) or the fantastical paintings of the Brooklyn Bridge and the early modern Manhattan cityscape by Joseph Stella (1877–1946). All the idealism and the melancholy that were proclaimed in Pittman's earlier series are reinvested into these daunting works, but they are expressed now with an almost orgiastic vitality.

The first installment, *A Decorated Chronology of Insistence and Resignation #1* (1992; **CATALOGUE 31**), established the ambitiousness of the series. At a formidable eight feet tall and a whopping twenty-one-plus feet wide, the four-panel painting is epic in its panoramic sweep. It is epic in its content as well. The first panel, reading from left to right, introduces a sort of manikin or artist's dummy or perhaps a Pinocchio figure—a being whose identity resides some-

where between humanity and its representation, or between life and art—who is incapable of telling a lie undetected and therefore always reveals the truth. Here Pinocchio is wearing both macho-man athletic garb—Jockey shorts and a tank top—and feminine frilly apparel around his legs and shoulders. He (or she) holds a placard designed to get the viewer's attention; it reads, "HEY!" In case this doesn't arrest the passerby, the image of an inflamed asshole spewing out a very pretty pile of shit likely will. The second panel introduces a new narrative phase. The anal imagery reappears, but now the feces that pour forth create the menacing image of a noose. A different placard surfaces; its text is "F.Y.," which may mean "fuck you" or "for you," as in "F.Y.I." (for your information). A raggedy, autumnal tree looms in the background. Clearly things have taken a turn for the worse from the gaiety and hurly-burly of the first panel. Distress dominates the third panel, as an "S.O.S." placard blares its plea amidst more excrement and a denuded winter tree. In the last panel Pinocchio reappears, but now a pale gray ghost of his former self and suspended upside down. The calamitous scene is a gaggle of arms, legs, butts, and body parts, with the placard "R.I.P." presiding over all, except on the far right edge, where a chorus of feisty "HEY!" signs pops up again as if to begin the narrative anew.

In Pittmanesque, operatic fashion, a grand cycle has been played out. The profligate, giddy fun and sexual escapades of the first panel have given way to an aggressive display—a confrontation with the audience, in truth—haunted by the specter of death; that episode, in turn, has been succeeded by a plea for help and compassion—but to no avail, for death ensues. Yet the signs of life persist, and life goes on regardless. We think of the death of individuals as tragic; yet there is nothing in Pittman's narrative that is any more dire than a natural cycle of life, followed by death, followed by new life, and so on. Indeed, this particular sequence ends with a surge of new energy. It is strangely, inexplicably joyous.

In at least some of the paintings in this series Pittman proposes a tonic for life. A motif that recurs frequently in the Decorated Chronology is the medical prescription sign,

Rx, a symbol of healing. What that curative potion might be is revealed in another motif, a textual one, that recurs in various places, as on the apothecary jars of *A Decorated Chronology…#9* (1992–93; <small>CATALOGUE</small> **32**): it is a three-part message—"2 Live"; "2 Work"; "2 Love"—that Pittman describes as "a prescription for living"; and in a true philosophical sense its three ingredients are the basis of a fulfilled existence. It is a most traditional idea of fulfillment, one worthy of Voltaire or Benjamin Franklin. In later works, such as *Like You* (1995; <small>CATALOGUE</small> **35**), a related image of a pair of praying hands—symbolic of hope, inspiration, and guidance—appears in conjunction with the Rx sign. Individually or in combination, these motifs indicate the dedication of Pittman's art to wellness, wholeness, and fulfillment.

These noble aspirations are not, however, the only driving forces in the Decorated Chronology. The grotesque euphoria that animates the Decorated Chronology like a fever is counterpointed by a tart undertone of anger at real conditions in the real world. In some measure the series is a response to the epidemic of Acquired Immune Deficiency Syndrome (<small>AIDS</small>): depictions of lurid sexuality and death litter the landscape throughout. Images of dysfunction and disease pervade, begging the unasked and unanswered question of who and what might be responsible for so much destruction—as if life, and death, didn't count enough to confront these issues. The series also satirizes the profligacy of our consumerist view of civilization itself. With garish caricature Pittman presents a delirious vision of a "cum 'n git it" culture that saves nothing and saves *for* nothing but wantonly consumes—and as wantonly discards—world events, human history, and the material past.

And too, these works may be a lampooning of what Pittman and many others regard as the "dumbing down" of American civilization. His overwrought portrait of contemporary society mimics the ghoulish sensationalism and vulgarity of tabloid television journalism and talk shows, with their lurid voyeurism and rampant celebration of all that seems monstrous and unnatural. He exposes the foibles and folly of a miscreant society that squanders the political

ideals and social tolerance that are—or were—its moral tradition. What remains in our societal self-image is a burlesque of America, a national freak show. To some extent the Decorated Chronology is a cautionary tale against the cheapening and trivializing of the ethos of democratic idealism and open-mindedness that (once) characterized American society to its own members.

There is no last word here: for all his uppity jabbering about what's wrong with society, Pittman is too generous, and too smart, to waste time issuing a stern rebuke to a heedless republic. As the "insistence and resignation" of the series's full title states, it is also a resignation, an acceptance of the screwy vitality of American culture and of the general habit of human beings to live as *humans* and not as ideal models of humankind. At heart the Decorated Chronology expresses the artist's willingness to celebrate the excesses and folly of human desire and its indulgence in the activity of living.

Pittman's consummate opus, the largest and surely the most ambitious in his oeuvre, bears the shortest and most direct title of all his paintings. *Like You* is a tour de force of interlocking and fragmented and layered images, which Pittman describes in almost sacramental terms as "a sort of altarpiece," complete with *predelle*, the small paintings or reliefs that often embellish the base of an altarpiece with depictions of the lives of the saints.

Here the main tableau is a thoroughly Pittmanesque vision of the vitality of contemporary life, a gamboling parade of androgynous pixies, body parts, helicopters, computer keys, brick walls—anything and everything. All-embracing and all-consuming in its volcanic energy, Pittman's Looney Tunes universe suggests less the lives of the saints than the raucous milieu wherein we mortals (including any saints among us) must live our daily lives and attempt to divine (as every saint must do) our individual purposes and the meaningfulness of it all. Counterpointing this ideological cacophony, each *predella* proffers a petite vignette emblematic of some domestic virtue: the homey pleasures of the hearth, the sitting room, the kitchen, and so on. Somewhere in this anatomy of the world, every human attribute is implied; none is precluded.

Not merely a travelogue, *Like You* is an uncommonly didactic work for Pittman, in which he addresses the viewer directly, as a fellow traveler, almost as a friend and confidant: "Like you," Pittman confesses from the opened pages of painted books, "I despair," presumably about any of the things that ordinary people despair about. He acknowledges experiencing "sometimes an overwhelming sadness," "a deep funky-funk" depression. But again, as in other paintings, he offers his recipe for life, proclaimed in campy gay humor: "Go girl! Grab it by the tail!" Pittman's joyous commandment is punctuated by a chorus of interjections, also in gay lingo, which effervesce with ecstasy for the fullness—and maybe even the *glamour*—of life itself: "Fabulous!" "Little black dress!" "Drop-dead elegant!" "Décolleté!" "Kiss, kiss!"

If Pittman is sometimes prickly and disdainful of modern life, his art is never blown by the bellows of self-righteous puffery or high minded piety. Always it is infused with charity, compassion, forgiveness, faith, hope, and kindness. Human life is always the decorated focal point of Pittman's art, and it includes all of us and him as well. Indeed, it is its very inclusiveness that makes his art so poignant, so vulnerable, and so heroic.

In his earliest paintings, the ones from the early 1980s which seem to have camouflaged their meaning in obscure biomorphic abstraction, Pittman had not yet found his artistic persona, his "voice." Those early works were not quite "Pittman"; or, as Pittman himself has mused, they were "not quite me." But now the declared sentiment is that the artist is "like you." Pittman does not consign himself, or anyone else, to the margins, to the outside, to the pathology of the body politic. It is as if his art were echoing Walt Whitman's incantatory desire that "what I assume you shall assume,/For every atom belonging to me as good belongs to you." Thus Pittman's art has come to an evolutional watershed from being "not quite me" to being "like you." Whatever lies beyond this watershed in Pittman's artistic development remains to be seen. But what is clear is that his tolerance, his acceptance, his celebration of life as it is lived by all those alive to do it, functions *together with* his most exultant idealism.

Pittman often vacillates between joyous celebration and caution, as if his art were both the acknowledgment of an ideal and the recognition of the impossibility of achieving the ideal. He is simultaneously an idealist and a realist, always upholding the finest virtues but ever mindful of how tenuous and fragile they may be. He longs for a community of shared beliefs and values yet remains wary of the tyranny of mass conformity. He wants the richness of an inherited culture in which abiding values and beliefs may imbue personal existence with a deep meaningfulness yet knows that individuals can be hobbled by the persuasions and credos of the culture into which they are born. He wishes for a society based on a foundation of order and civility but readily concedes that "the world is shockingly chaotic and random." His paintings are a heartfelt portrait of American culture in the present day.

Yet he denies that his art is chaotic. "If there is one element in my work that I know is not of that Protestant side of me but is clearly more Catholic or perhaps Latin American, it is that so many things are happening at once.... In Mediterranean and Latino sensibility the cognizance of time is so much more about simultaneity than about episode or sequentiality." What an Anglo-Saxon or European sensibility might "label as chaos in my work... I see as simultaneity and not chaos. I've never viewed my work as chaotic. It's very ordered and about what might appear to be opposites but occurring simultaneously and occupying, very happily and with no problem, the same pictorial space....I always find it curious when the work is described as chaos, and I realize that view is about how you look at time."

Pittman comments that a deep and abiding aspect of his art is its bittersweet vision of human existence; yet that fundamental aspect is often overlooked or sidelined in discussions of the work. And this, he says, likely has to do with a European-derived sensibility of time: "North American culture by and large does not indulge in the development of the bittersweet, but certainly that is very much a part of other cultures. Implied in the concept of 'bittersweet' is that something can be bitter and sweet at the same moment." Pittman, then, aims for the larger

picture, a humanistic overview of simultaneous realities and contradictory truths. His art is a celebration of difference and sameness, of the self and the other, of the one and the many. His art stands, not for one *or* the other, but for one *and* another.

Is it likely that any of his fervent message is intelligible to viewers? Pittman believes the paintings are "very generous, very helpful" to viewers in retrieving meaning from the decorated surfaces that stimulate our visual and imaginative attention. He adamantly asserts that "the information that inhabits the work is absolutely public domain," that is, his works are composed of popular, even vernacular, imagery that is easily recognizable, culturally viable, and richly associative in quite standard ways. What could be more universally understood than, say, two lovers embracing, a ship setting sail for unknown shores, a candle burning brightly in the darkness; or more readily recognized than the Visa and MasterCard logos, the pharmacist's emblem of the mortar and pestle labeled "Rx," and the body imagery and phallic symbolism that appear so frequently in his art? The potpourri that comprises Pittman's iconography—microscopes, owls, nooses, silhouettes of Victorian ladies and gents, flowers, queens, coffins, cityscapes, landscapes, Jockey shorts, etc., etc.—are hardly esoteric or privileged information. No academic training is necessary to enjoy them visually or reflect on the associations and meanings they convey in combination with one another.

The whole moral enterprise of Pittman's art is not to instruct but to enable the viewer to discover, and to revel in, the complexities and contradictions, the simultaneous differences and samenesses, by which people establish their own sense of self-identity and understand the identity of others. Pittman's art is a wholesale attempt at sharing: sharing experiences, sharing differences, sharing visions of reality. It is a remarkably generous and trusting act. Making and setting his art before the viewer is Pittman's gesture at establishing a union with the viewer and with the audience at large, which is our society and culture. His project as an artist goes beyond some communications theory involving the loop of message sent/ message received; it is an allegory of love. Pittman's aim is not the transfer of information or a

political viewpoint, but the sharing of experience and insight; it is not communication that Pittman intends, but communion.

His art shares the qualities of visionary utterance. It is part prophesy, part dream, part speaking in tongues, and to any pragmatist, altogether impractical and unrealizable. The artist is diffident about the description: "I'm not allergic to the word *visionary*, though I think that it's a hard word to use because it can be misconstrued very quickly as reactionary. The only reason I have a problem using the word is because I don't want it to appear as self-aggrandizement. It's not. But I think that it *is* a core of the work." And as far as calling his art visionary, Pittman adds, "I'd rather let someone else say that." So he is perhaps a closet visionary, maybe one who has been outed. For whatever hesitance Pittman feels about calling the work visionary, he is willing to describe his art as an "impractical recipe for a better psychological world," and, again, "a most unpractical recipe of how life could be."

In an all-encompassing vision of human existence, Pittman sets forth his transcendent aspiration for humankind. His art is a conjuring forth, an idealistic pining for things so fragile and evanescent in the world as beauty, virtue, and harmony with life and with death that it is sometimes only through art that they can be expressed. With unabashed and noisy sentimentality Pittman celebrates artistic creation as the most joyous exaltation of the human spirit. It is joyful noise, indeed.

The Self-Reliant Seductress Visits the Museum

DAVE HICKEY

1
PRETTY EYES,
A MOUTH,
AND A GREAT PAIR OF LEGS

It is perhaps true, as Ruskin or Le Corbusier's anonymous teacher would have suggested, that to deal with whatever ornament might be strikes at the very core of the visual experience, where that core is not skewed by taste, snobbery, ideology, social convention, ecclesiastical or political restrictions, stylistic salesmanship, and all sorts of other refinements that limit the emotional and sensory freedom of each viewer....It is a discourse of love.

— OLEG GRABAR, *The Mediation of Ornament*

Writing about Lari Pittman's paintings should be easy—and it would be, if the paintings seemed to invite commentary or require it. But they do not. They need only be seen, and, once seen, their combination of gnostic difficulty and visual availability tends to suppress any vagrant urge toward explanation or advocacy. One longs for time to spend with them, not words to explain them. And why gild the lily? one asks, when the best a critic can offer is the observation that Lari Pittman's fate, for worse or for glory, is to be a profoundly American artist at a moment when American art has reverted to its original condition of colonial insecurity—has taken to aspiring, once again, as it did in the eighteenth century, toward fashionable European models of thought and action.

This is all you really need to know: that, in this moment of transatlantic flutter and swoon, Pittman remains an American democrat—irrevocably Emersonian in his pancultural openheartedness and his proclivity toward rapture—most Emersonian of all in his unwavering commitment to "the infinitude of the private man," who must of necessity subject philosophical theories and utopian wishes alike to the "critique of everyday existence." Thus, in the iconography of Pittman's paintings the daily necessities of love and work tussle in gorgeous array with the

dreams and beliefs that populate yesterday and tomorrow—and everything is tested against the Ethical Imperative—against Emerson's primary question: "How should I live my life in this American moment?"

One need only scan the titles of Pittman paintings, in fact, to compile a succinct catalogue of peculiarly American intellectual preoccupations—a short-title history of American culture: *Colonial Power; The New Republic; Tending the Farm; Farming the Self; The Veneer of Order; Reason to Rebuild; Where Conscience Will Be Reshaped by Intuition* (5287 A.D.); *Where Sentiment and Sentimentality Will Reshape Conversation* (5732 A.D.); *The Sounds of Belief, to an Atheist, Are Very Touching; The Senseless Cycles, Tender and Benign, Bring Great Comfort; This Landscape, Beloved and Despised, Continues Regardless; Transcendental and Needy; Beatific and Needy; A Decorated Chronology of Insistence and Resignation.*

Beyond this bit of intellectual cartography, however, the best a critic can offer by way of lending expertise is to note that one's experience of Pittman's paintings is probably enhanced by a casual familiarity with twentieth-century American painting, sculpture, design, and folk art—with Golden Books, Clip Art, *retablos*, and lowriders, with Norman Rockwell, Bob Kane, and Chuck Jones—Joseph Stella, Matta, and Stuart Davis at their most effusive and effete, Shaker furniture and Donald Judd's sculpture, as well, at their most eloquent and devotional. Such familiarities, however, are so little specialized as to be almost unavoidable, and one serves easily in place of the others in nearly every case.

Otherwise, there are no prerequisites for looking at Pittman's paintings. No historicized overview of their chronological "development" is required to appreciate them singly. Nor are there any deeply encoded social or professional impediments to understanding them, unless, of course, you consider the absence of impediments itself an impediment—on the principle that Pittman's failure to disqualify *any* beholder of his art must necessarily disqualify anyone precertified as an "elite beholder." In which case, Pittman is lost to you, since, in point of fact, his paintings do not even presuppose any particular interest in, or respect for, the visual arts. Grounded as they are in the

decorative vernacular of this century, they never propose to redeem the work that goes into them by elevating it to the status of "art," but, rather, to redeem the languishing practice of "art" by investing it with loving work.

So, Pittman's paintings do not "critique" things, nor are they ever about "painting itself" or "art itself" or "representation itself" or "history itself"—or, even, "decoration itself." In fact, if these paintings are about anything, they are about art as a way of conducting oneself in an ethical way, with maximum generosity and forgiveness, by making art that gives and forgives as well. Thus, each of Pittman's works constitutes an instrumentality through which the artist makes his way in the world and strives to maintain a decent relationship with it. And each painting makes its way as well. It is sent out into the world alone, toward some domestic destination, endowed by its creator with the wherewithal to attract our attention and sustain our interest in its complex content for the length of time required to appreciate it—and even beyond that time, hopefully, into some new time and place where its content might be reconstituted by that new context. *Where Achievement Will Be Measured by Contribution* (4175 A.D.), if you will.

Thus, as anti-Platonic as it seems, I think we must regard Pittman's penchant for creating unrepentant, self-reliant objects of desire as an acknowledgment of his painting's intrinsic difficulty. There is a primary, rhetorical level, of course, at which this cosmetic eloquence merely signals Pittman's commitment and devotion to his argument—the advocate's willingness to invest in the case he is pleading. (Cicero would argue this, and correctly, I think.) But over and above this embodied advocacy I think we must also consider Pittman's visual dazzle as mitigation for his gnostic complexity, as a compensatory gift aimed at providing us with sufficient visual resources to sustain our extended, casual contemplation. Most crucially, this proliferation of visual incident and pattern seems aimed at maintaining a relationship between the beholder and the work that responds to the accretion of long acquaintance—and subverts the disembodied products of scientific scrutiny and hermeneutic analysis.

So, finally, even though there are no prerequisites for looking at Pittman's paintings, a certain amount of attitude adjustment is required in order to distinguish their decorum from that of contemporary practice and to compensate for the unrequited milieu of the contemporary *kunsthalles* where this exhibition of paintings will be seen. Because the kunsthalle is not Pittman's natural milieu. His paintings are designed to sustain themselves singly, privately, in long-term domestic relationships. They aspire to l'*intimité héroïque* and, as such, propose themselves as the absolute antithesis of the academic postminimalism that constitutes standard kunsthalle fare at the moment.

This brand of postminimalism, of course, is designed specifically for the institutional quick-take and must, of necessity, go all the way on first glance. It is "fast art" to be glimpsed, gotten, and if not forgotten, contemplated in recollection or reproduction. So we walk into a white room. We confront an aggregation of medicinal eye-candy (sometimes quite literally). It is arranged in tasteful dishabille. We note the way it furnishes the space and hastily infer from it some theoretical *aperçu* on the inequities of contemporary culture. We move on to the next showroom, shopping for insights. That's how we do it, and by now such drive-by, artistic encounters constitute a ritualized cultural scenario.

Thus, the experience of confronting a painting by Lari Pittman, in the midst of this ritualized behavior, is like being introduced to someone beautiful, interesting, and neurotic at a faculty tea. You exchange a few words and make eye-contact. Suddenly something very strange and very complicated is happening. It is exciting, but somehow not that pleasant in the context. Still, it's about to get bright and sexy when you notice the dean standing over there sipping his sherry. And you have work to do. So you think, "Jesus, I don't have *time* for this." And, in truth, you don't, not at the faculty tea, nor in the kunsthalle either. So you just let go and drift away unrequited. You engage in more "serious," goal-oriented activities, but you keep glancing back. You experience *tristesse, schadenfreude* even—unusual and inappropriate sentiments for an institutional cultural experience.

This complicated and anomalous response, however, *always* arises when we confront things that challenge our conventional ways of knowing them. Once, in fact, this was the very experience we sought from art, that jolt of defamiliarization, and experiencing it now should remind us that works of art are *still* more complicated entities than we currently wish them to be: they are objects, but they are not things, since they embody personal and cultural meanings. They are language, but they are not writing, since their meanings, like those of speech and music, are embodied in phenomenal signs. Thus, any effort we make to treat works of art as material things (surrounded by clouds of cultural significance) or as immaterial not-things, like writing (which signifies absent signifiers), imposes a mind/body split upon cultural entities whose language and body language are so inextricably intertwined that the knowledge we gain of them is always some imperfect blend of physical intimacy and intellectual understanding, never perfectly one or the other.

All of which is to argue that Lari Pittman's habit of assigning the attributes of "personality" to his paintings is neither as casual nor as cozy as it might appear. The virtues of art for Pittman are always those of character and sentiment; and these virtues are routinely expressed in a vocabulary of "personality" that arises directly from the ethical and emotive language of embodied meaning—the discourse of classical rhetoric that directly informs the history of European painting. It is a language that is spoken through one's physical presence in the cultural world and read through the accretion of acquaintance. And the ways that we respond to works of art, I would suggest, are more closely analogous to the ways we respond to living personalities than to the ways we respond to things or to pages of text—or even to fictional "characters" whom we may know well, but not that intimately. At best, we know works of art, as we know members of our family, intimately but not that well.

So Lari Pittman is not kidding when he insists that a successful painting should have "pretty eyes, a mouth, and a great pair of legs." (Or when he proposes, as he did to me, that one might wish to perform cunnilingus on a particular painting.) Such proposals amount to no more, or less, than

sexualized versions of the argument put forth by seventeenth-century French colorists to confute Platonic academicians, who argued for the priority of line over color, who held that painting, insofar as it was a valuable, philosophical instrument of public virtue, consisted of the intellectual organization of linear significations, which sadly could only be rendered visible by the cosmetic application of color.

These colorists, not surprisingly, argued that to be successful the *physical* painting (its color and textures) must fully embody the painting's intellectual content, as the body and voice of the successful orator embodies his argument and exemplifies its ethical appeal. In this way, the colorists, ever so faintly, injected republican politics into the argument between "conceptual line" and "physical color" by insisting on the distinction that Quintilian makes when he argues that, even though the intellectual organization of an oration may render it "philosophical," the exemplary body and voice of the orator are required to render that philosophy eloquent (which is to say, "political")—and only embodied eloquence is worthy of a democratic forum.

Pittman's forum, of course, is the domestic menage, and his "ideal orator" is probably closer to Hawthorne's Hester Prynne than to Marcus Tullius Cicero, but the antique argument of the colorists, I suspect, is not too far from Pittman's attribution of "pretty eyes, a mouth, and a great pair of legs" to a successful painting. "Pretty eyes": to simultaneously see and be seen, to acknowledge and attract the beholder. "A mouth": a cavity, another sexual invitation, but a pictorial space as well and a chamber for the voice to address the issues (with the caveat that the words flying out, off, and across Pittman's paintings are both confirmed and constrained by the body language of the painting itself). "And a great pair of legs": again, to impress the beholder but this time with the painting's strength and mobility, its self-reliance and independence. Without these attributes, I would suggest, the work has none of the character required to invest its philosophical argument with bodily eloquence, and in a forum of equals this is the only argument we accept. We refuse the instruction of authority and the thin rubric of explanation. We will only be taught by the embodied example of our peers.

2
THIS HISTORY LESSON,
BELOVED
AND DESPISED

Some writers have so confounded society with govern-
ment, as to leave little or no distinction between them;
whereas they are not only different but have different
origins. Society is produced by our wants, and government
by our wickedness; the former promotes our happiness
positively by uniting our affections, the latter negatively
by restraining our vices. The one encourages intercourse,
the other creates distinctions. The first is a patron,
the last is a punisher.

—THOMAS PAINE, *Common Sense*

At the beginning of this essay I characterized
Lari Pittman as an American artist in a European
moment and suggested that his work poses a practical
challenge to the entrenched routines of making and dissem-
inating art in this moment. Specifically, I wish to suggest
that Pittman's work aspires to alter governmental assump-
tions about art by publicizing the desires of its social
constituency. In doing so, Pittman's reversal of current
practice alters the way that private and institutional
accreditation cause and effect one another in our experi-
ence of Pittman's work.

So, to begin where we are: consider the historical func-
tions of the "public art exhibition" and the "texts" that
usually accompany it. Neither are neutral occasions. Both
are vestigial inheritances from the Enlightenment, during
the course of which those who mattered decided that pri-
vately produced, speculative works of art might contribute
to the public good in the same way that works of literature,
similarly produced, had begun to do—but only if the pub-
lic who witnessed such works of art could be shielded from
their spectacular nakedness by a bodyguard of literature.
In this way the "public art exhibition" was born out of
generous public spirit—and the "catalogue essay" out of

a profound distrust of images and the public's ability to
cope with them.

In the wake of the American and French revolutions,
however, the nature and function of such exhibitions
(and their linguistic fig leaves) took on different aspects in
Europe and in the United States. Each system would par-
take of the other, of course, but the ultimate source of art's
public authority would remain distinct. Europeans would
continue to regard public exhibitions, as they had before
the revolutions, as instruments of the aristocratic academy
dedicated to elevating public taste by making available
works of art reckoned virtuous by the guardians of national
culture. Public taste itself played no part in this practice,
since the essence of the nation's character was presumed to
reside in its professional civil service, whose task it was to
realign private pleasure with the public good.

Americans, on the other hand, created a new art cul-
ture that conflated aspects of republican government with
market economics. They allowed works of art to be *voted*
into esteem by private citizens who were willing to invest
money or words in them. Then, on occasion, the "best" of
this work was selected from private holdings to be exhib-
ited in institutional settings as emblematic of public virtue.
This practice, of course, routinely compromised the disin-
terested "integrity" of everyone involved in it. But the sys-
tem was not *about* the disinterested elevation of public taste.
It was *about* "conflict of interest" and the resolution of those
conflicts—about selectively recruiting objects of private
desire in the cause of public virtue.

Democratic institutions, after all, were *supposed* to be
fluid. Civil servants were *supposed* to be responsive to the
populace, who embodied the nation's character. Moreover,
Emerson was there to remind us that all official construc-
tions of the public good must be subjected to the test of pri-
vate happiness. And the virtue of the American system was
that it worked, not at a grand public scale, not with marble
halls and a professorial aristocracy, but it worked. It was
conducted in a small world of people committed to visual
culture, and this world was undeniably private, profligate,
unaccredited, and a little silly, but it was not elitist. Or
rather, it was only elitist in Emily Dickinson's sense—that

the soul selects its own society. Even so, for nearly a hundred years, from Frederick Edwin Church to Andy Warhol, this system sustained American visual culture in a state of dynamic instability and, in keeping with its hybrid character, produced artifacts in which the iconography of public virtue and private desire commingled in shifting measures.

The system ran on a serve-and-volley of artistic style-shift and institutional retrenchment, and it guaranteed change; in fact, once an institution agreed to exhibit some radical artist in response to a secular constituency, change was a *fait accompli*. Civil servants scrambled to adjust. Artists prepared to readjust, and everyone called it progress. But change, not progress, was the drug, and anxiety was its bright reward. For worse or for glory, then, this assumption of inevitable, extrainstitutional, socially motivated change distinguished the American system from the European, whose cardinal virtue has always been that it does *not* change. Unfortunately, the European system doesn't work either. At least not in the United States, where it is currently in place and where thirty years of postminimal, governmental evangelism has not elevated public taste one centimeter. Nor has it improved the state of public virtue, unless one conceives some public benefit in the proliferation of Barbara Kruger's trademark Helvetica.

Lari Pittman's work, then, presents us with an American situation in a European moment. Its empowering constituency is secular, eclectic, and social rather than educational or institutional. Moreover, it brings with it into the public sphere the ethic and discipline of a private mercantile culture. As Warhol brought the ethic and supposedly degraded culture of advertising into the art world, as Richard Serra brought the ethic and supposedly degraded culture of the steel mill, so Lari Pittman brings the ethic and supposedly degraded culture of the interior decorator's shop, embodying its rhetoric and iconography in paintings whose undeniable character and accomplishment remain problematic by the standards of our institutions. In a situation like this, then, the standard European function of the "catalogue essay," that of justifying supposedly difficult art to a supposedly degraded public, is not only unnecessary, it is ludicrous.

One may, at best, call attention to the problems of confronting Pittman's paintings in a denuded, public setting with insufficient time to establish any real acquaintance with them. Beyond this, instruction in "reading" Pittman's painting is a form of theft—stealing pleasure from the public—for even though one could enumerate the private pleasures of these paintings at considerable length, the real question is how this benison of private happiness tests and alters our construction of public virtue, how Lari Pittman's paintings, by redeeming the vernacular in public, might ever so slightly reconstitute the cultural world at a historical moment when the undeniable virtues of that vernacular are routinely presumed to be vices in the practice of high art.

Presented with a dynamic situation like this, however, one cannot avoid the presentiment that things are about to change—again. So it helps to recall the consequences of the last, great paradigm shift in American culture, when, during the 1960s—not long after its break from the modernist past—America's high visual culture began to consolidate itself into a single entity and separate itself from the culture-at-large. At that time an apparently benign sequence of stylistic innovations culminated in a dire complex of institutional ones; and somehow in the process of replacing a "naturalized" concept of art with a more "conceptual" one, we inadvertently replaced a socially constructed art world with a governmental one—a new art world, as Tom Paine could have told us, less concerned with our wants than with our wickedness.

During this period the traditional dynamic relationship between the art community and the community of artists (who sought to reform it from outside) began to dissolve. The "outside" disappeared. The American idea of an anxious, turbulent, semimercantile, semi-institutional art world, in which society and government—private pleasure and public virtue—rhetoric and philosophy—were allowed to overlap and hopefully coalesce, disappeared along with it. Young postminimalists, having deconstructed their products out of theoretical revulsion for rapacious commerce, began seeking refuge in new public art institutions that were springing up like franchise cloisters. Effete popsters, in flight from this cult of disembodied virtue,

began seeking redemption elsewhere, in the democracy of desire, the turbulent marketplace.

It was a body/mind split, of course, but it manifested itself as a political argument, and the issue at stake was clear: America was one world or two. It was either one complex civilization or two cultures counterpoised, either a loose, mercantile confederation akin to the Venetian Republic, existing at the interface of East and West, in which high culture aspired to the ebullient elaboration of a heterogeneous vernacular (as the San Marco is an elaboration of any merchant's palazzo), or it was two ideological cultures wrapped in fatal embrace, like Weimar Germany, in which high culture strove at every turn to repudiate the lumpen vernacular.

Dialectical Weimar won, of course, and in the groves of American high culture, that antique European model of an aristocratic/academic high culture was fully adapted to new purposes by a simple change in nomenclature. "High" and "low" were replaced by "good" and "evil," "intellectual" and "populist," "progressive" and "reactionary." But the structures, attitudes, and practices remained intact. In this way America lost its youth a lot faster than Venice did, and the idea of a Venetian America lost big time. It seemed, for a while, to be lost forever.

3
AN AMERICAN PLACE

Natural laws we shall never modify, embarrass us as they may; but there is still something in the nobler or less noble attitude with which we watch their fatal combination.

—WALTER PATER, "Winckelmann"

On a beautiful winter afternoon about ten years ago, I found myself strolling through the Museum of Contemporary Art in Los Angeles. At that time this institution was an upscale kunsthalle of the very latest design; and so (as was the custom in those days) I was happily reading the walls, doing the math and reveling in sensory deprivation when I drifted around a white corner and bing! Looming up in front of me, glowing with Southern color and awash with floral and architectural ornament, was this enormous, decorative *painting*; and in that context, at that moment an elephant would have been less surprising. Here, in this space seemingly devoted to the provincial critique of public virtue, was this worldly celebration of domestic feeling. Here, in this moment of pathetic sentiments, ephemeral materials, and modest scale was this extravagant, tightly designed, heroic object!

Consulting the card on the wall, I discovered that the painting was titled *An American Place* (1986; CATALOGUE **14**), that it was painted by one Lari Pittman (b. 1952, Los Angeles), whom I did not know, but who was obviously an artist for whom the surfaces of things spoke volumes—for whom the words *volute*, *cartouche*, *sconce*, and *rocaille* must conjure up a world of meaning. "Here," I thought, "is the work of a certified Venetian." Because the painting had that aura of exotic toughness—like a wild orchid sprung up through a crack in the pavement—the knowing "doubleness" that always informs artifacts of the redeemed vernacular, from the San Marco to Marlowe's *Faust* to Whitman's *Leaves of Grass* to Warhol's *Mao*—the language of the street bubbling just beneath the sleek artifice.

The street language being spoken in *An American Place*, of course, was that of Los Angeles, probably that of its secretive hills; and, in that enigmatic atmosphere, the free spirits of Erté, television, and Stuart Davis mingled easily with the "tasteful sophistication" of *House & Garden* '59. Clearly, Pittman's painting was the work of a pop sensibility, but of a pop sensibility without guilt; for, unlike the chillier products of sixties pop, Pittman's work declared its decorative impulse openly and embraced its sentiment without shame—renouncing the deniability of camp with its closet-discourse of "I know that you know that I know." In the trendy, cynical sixties this veil of irony had defended deep reservoirs of honest sentiment in paintings by Lichtenstein, Warhol, and Wesselmann. In the surly, ignorant eighties, however, Pittman was shrewd enough to drop the veil and just give it up, to "pine away in public like a sixteen-year-old girl," as he put it, knowing that it would work.

So there was no question of "I know that you know," etc. You just *knew*, without reflex or hesitation, that, although some responses to Lari Pittman's painting might be more nuanced than others, there were no "wrong" responses to it nor any venues where it could not hang. And these attributes of desirability and mobility would have never occurred to me, I assure you, had my first reaction been something other than *I want to take it home*— had I not been surprised by this response and realized in that moment that I had long since abandoned the prospect of being surprised by desire in a kunsthalle. But here was young Pittman, obviously the child of a lost pop vogue, an evolved devotee of "retail chic" and that moment in American culture when the idea of privacy and self-sufficiency presented a ravishing prospect to its young artists, when the idea was to move away from home, get out of school, start a little business in images, and stay away from the museum.

This sensibility had expressed itself in Oldenberg's Store, in Warhol's Factory, in Ed Ruscha's business cards and his paintings of flaming museums. The motto of those times was "An Honest Product for an Honest Price"— appropriated from some car dealer in the Valley—and

I recognized its provenance in Pittman's crisp, sincere facture, and in the fact that, despite its retail aspirations, Pittman's painting was obviously flourishing in its museum incarceration. As you knew that it would anywhere. There was no question about it. If Pittman hadn't sold the painting to a museum, you knew that he could have sold it to a collector in Beverly Hills or to a hair salon in West Hollywood or to a motel in the Valley.

An American Place would have hung in each of these American places with equal congeniality and remained just as intelligently insouciant, just as irrevocably American. Because even though *An American Place* was notoriously inappropriate in the museum, its shrewd pastiche of floral and architectural detail was so exquisitely evocative of the palm-ragged city beyond it, so perfectly in tune with the palpable atmosphere of Los Angeles, that the painting itself, far from seeming incongruous in the space, conspired with the surrounding sprawl of city to make the museum itself seem contrived. No painting had done that for me since Rosenquist's *F-111*, and, in truth, in this aspect, *An American Place* was a subtler and more provocative instrument. It deftly repositioned the city of Los Angeles as an American place in a larger, older, and more complex world.

It saw the city in American English, but it glimpsed the city in Spanish as well, with Moorish overtones, as the *Ciudad de Los Angeles*, a semitropical metropolis sprawling at the edge of the great Pacific, in the northern latitudes of Hispanic America, at the western extremity of Mediterranean civilization. So even though it was still America—fast food, short attention span, and all—it was an American place in which the pristine enclosures of the new kunsthalle lost their rigid, arctic authority and took on the flimsy insubstantiality of temporary exhibits themselves. You could almost hear the docent chattering: "In the dark forests of Northern Europe, you must remember, the natural environment is crowded and shaded, and the climate is such that the sun rarely shines. So you can understand perhaps why empty, white enclosures of this sort have gradually taken on metaphysical significance, have come to symbolize, not just moral purity, but spiritual transcendence, Protestant virtue, and philosophical rigor as well."

This effect, I decided, was a classic demonstration of what happens to critical architecture when confronted by informed eloquence. The museum, as museums are prone to do, proposed itself as a critique of both the artifacts within it and the city beyond it. Pittman's painting, having been designed to hold its own in that city, never even *noticed*. It simply ignored the blanched laboratory and addressed the spectator, who thought, "What the hell? What better object to remind you of your eyes than this gorgeous expanse of West Hollywood *wallpaper*? What better counterpoint to ghostly, academic signage than this sleek celebration of nothing more, or less, significant than the bittersweet pleasure of a twentieth-century morning in Southern California?"

At this point a young woman standing near me, also looking at the painting, muttered, "Decorative shit," and stalked away. There was nothing to be done about it, I decided. As long as our experience of art remained imperfectly socialized, decoration would always signify corruption since the whole *idea* of decoration as a defective practice presumed that something natural or spiritual or virtuous (or all three) was being defaced or occluded by the phenomenal appeal of its ornamental surface. Some spiritual flight was being grounded by the seduction of material complexity. Or some pristine natural thing was being defaced by the obsessive noodling of a corrupt culture. Or some serenely elegant, although unfortunately absent, intellectual signification was being occluded by the distracting complexity of the embodied sign.

So, as long as the meanings of art are presumed to reside elsewhere—*within* the object or the materials, *behind* the surface of its signifiers—decoration would be taboo and would remain so as long as any art object was considered virtuously nondecorative. Because if any works of art are acceptably social and decorative, all of them must necessarily seem to be. And if all works of art are social and decorative, then the sculptures of Brancusi would be decorative (which they demonstrably are) and we could no longer attribute to them the meanings we wish to. So decoration must remain an impediment to disembodied reason and the good life, as Plato argues, or a perversion of our "natural"

relationship with the materials of history, as Guy Debord implies, or a crime against the spirit of good design as Adolph Loos insists, or, as Tertullian argues in *On Spectacle*, an instrument of the devil: "For who else would teach us how to alter the body, but he who by wickedness changed the spirit of man? Whatever is born naturally is the work of God. Obviously then, whatever is added artificially is the work of the devil. What a wicked thing it is to add to a divine work the inventions of Satan."

All of these constructions, however, presume the world as we know it to be a simpler place than it is. Each performs one form or another of the body/mind split. Each presumes that the meanings we seek are either absolutely within the thing or totally absent from it, fully embodied or irrevocably elsewhere, so either the volumetric essence of some natural/spiritual object is being defaced, or some absent intellectual/spiritual signification is being occluded. Pittman's painting, on the other hand, simply refused to posit art's authority in its message or its materials, presuming it to exist in the quality of our acquaintance with its complex appearance, reconstituting the experience of art as a *social* occasion dedicated to the resolution of private desire and public virtue, in which the work's surface embodies the artist's devotion and commitment, the subject's public and private complexity, and the beholder's curiosity and desire.

As I walked out of the museum, I found myself thinking about a picture by Edward Hopper called *Excursion into Philosophy*. In Hopper's painting a fully clothed man sits with his elbows on his knees on the edge of a single bed in a bare room. He is staring down at a rectangle of angled, afternoon sunlight that is falling through a window (to the right) and onto the floor. A book lies open on the bed beside the man, and a woman is stretched out behind him, sleeping. She is nude from the waist down and turned away from us, facing the wall, so we only see the lower half of her torso from the back. And that's pretty much it, as far as description goes, and taking the painting's title into account, Hopper's message would seem to be

equally succinct: "Here, in this embodied world, in this angled light, amidst these physical relationships and in this atmosphere of attenuated passion, philosophy begins. And there, where you stand in your own moment, before this physical image of that physical moment, philosophy ends. This marks the trajectory of its excursion."

And in my own moment, walking out of the museum into the sunshine, this cycle of embodied and re-embodied meaning spoke directly to my experience of Pittman's painting. There was not much space for the intercession of text in this transaction, and I took this as Lari Pittman's first gift to me—and I resented it a little. I felt that Pittman's painting was, somehow, more interesting and exciting than it should have been, that I should not have been so surprised and delighted to find it there. But this, I knew, was just the conservatism of the moment, another way of saying that in a better world such paintings would have been there all along, and there would be more of them.

And this, I suspect, is the single, true response to social art in its moment, because by the rules of the game we neither long for that better world nor look for it, lest our constructed expectations cause us to overlook its inevitable surprise. So we affect a kind of boredom, a condition of desiring desire, never knowing what it is we want until we see it. And, when we see it, of course, it always seems to be something we have, somehow, just stopped hoping for. And having recovered the image of this new, but somehow lost desire, we are inevitably of two minds about it, grateful to have it now before our eyes but still petulant at not having it sooner. For we are changed in that transaction, and soon, but never soon enough, the institutions and practices that surround this new occasion will change as well.

Catalogue
of the Exhibition

THE ARTIST DEDICATES THE EXHIBITION
TO ROY DOWELL.

Works are arranged chronologically, according to the artist's records.
Titles, particularly of individual works included within series, which may have been published elsewhere in modified format,
have been standardized here by agreement with the artist. Dimensions are in inches, height x width x depth.

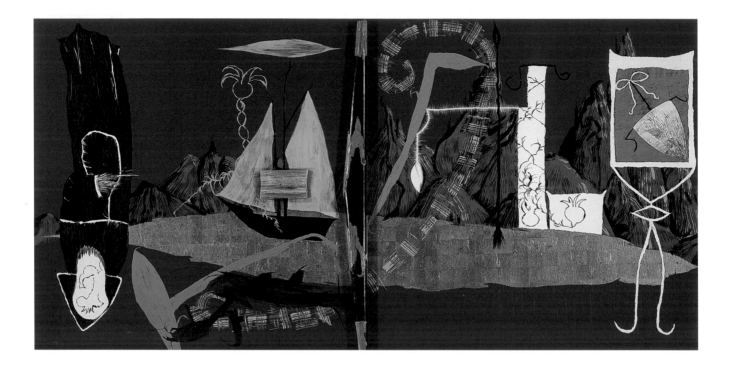

1

NETHERWORLD

1982

Oil and acrylic on canvas with wood

76 x 152 x 18 in.

Lari Pittman, courtesy of Regen Projects,

Los Angeles, and Jay Gorney Modern Art, New York City

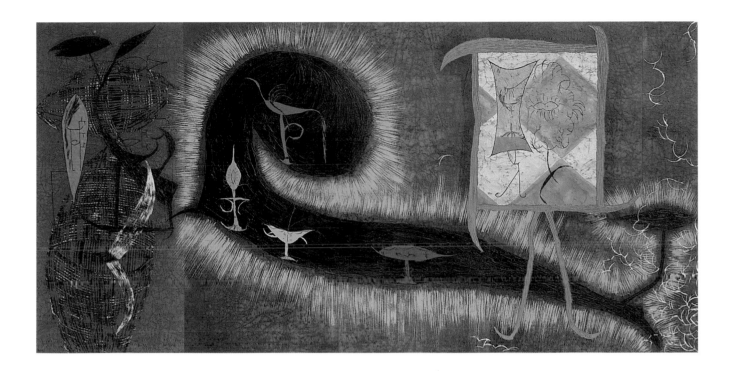

2

FROM VENOM TO SERUM

1982

Oil, acrylic, and cloth on wood panel

48 x 96 in.

Rosamund Felsen

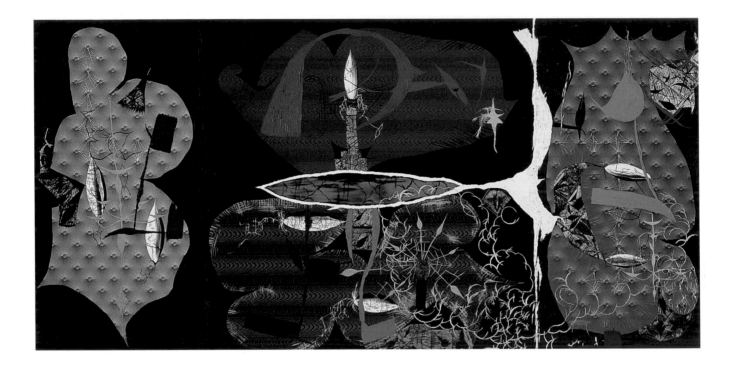

3

MALADIES AND TREATMENTS

1983

Oil, acrylic, and gold leaf on paper mounted on wood panel

53¹/₂ x 108 in.

Gary and Tracy Mezzatesta

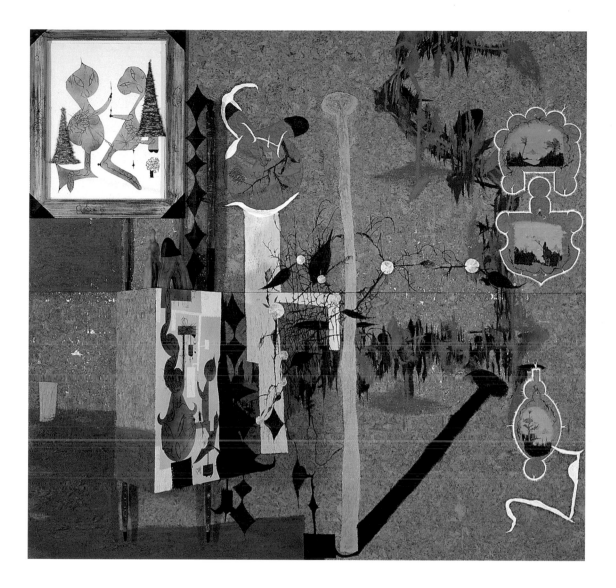

BIRTHPLACE
1984
Oil, acrylic, and objects on paper mounted on wood panel
104 x 108 x 18 in.
The Eli Broad Family Foundation, Santa Monica

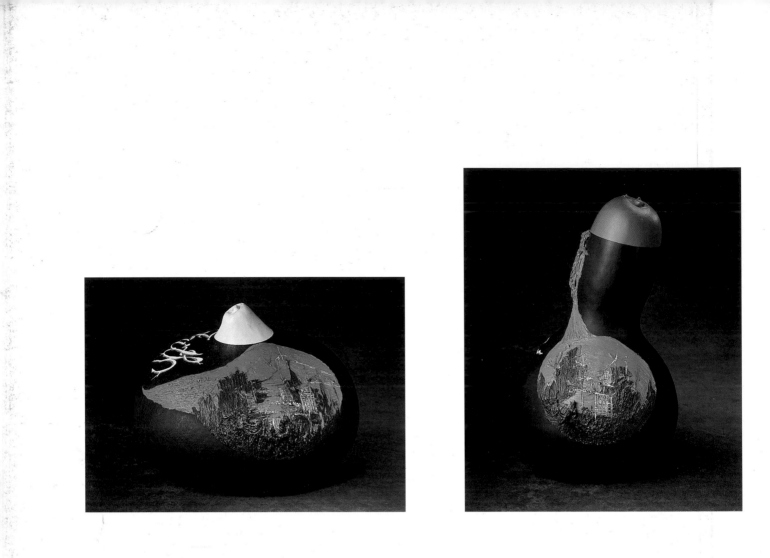

5

FAITH
1985
Painted gourd
8½ x 11 x 11 in.
Private collection

6

HOPE
1985
Painted gourd
14¾ x 8½ x 9 in.
Sula Fay Bermúdez-Silverman

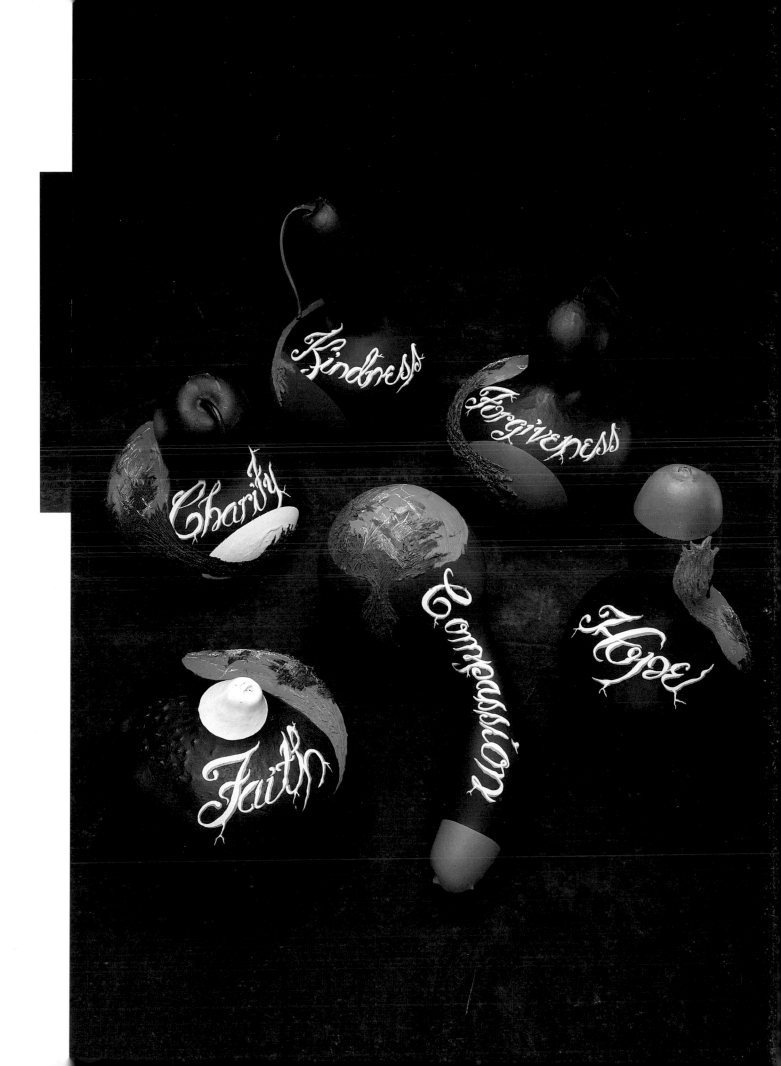

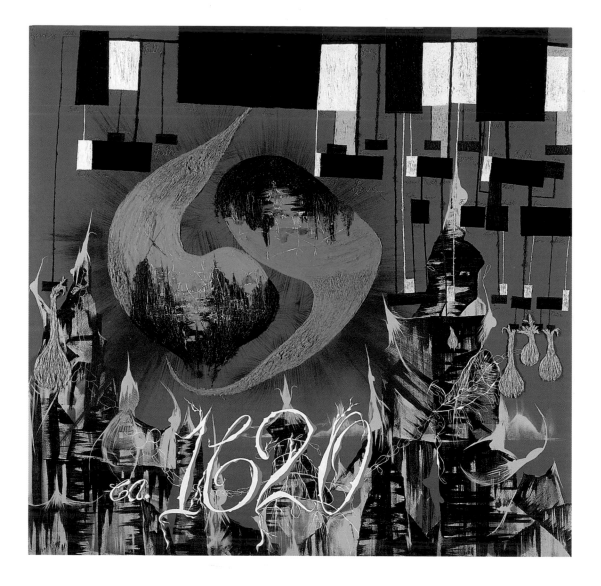

//

PLYMOUTH ROCK 1620

1985

Oil and acrylic on wood panel

80 x 82 in.

Mike Kelley

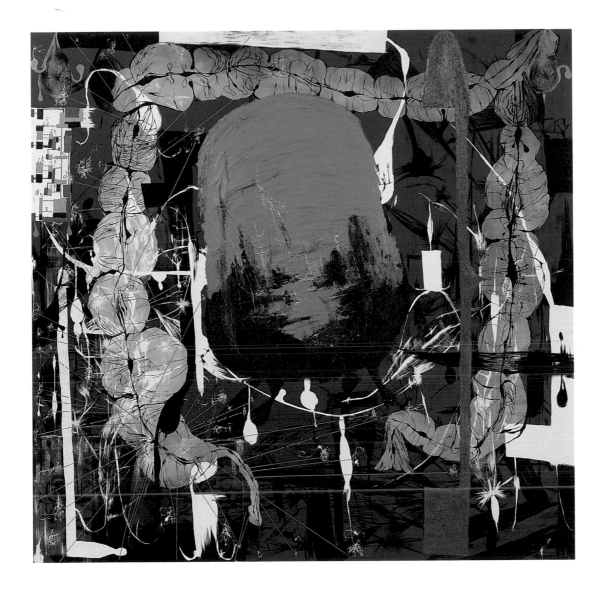

12

THE NEW REPUBLIC

1985

Oil and acrylic on wood panel

80 x 82 in.

The Newport Harbor Art Museum, gift of Mr. and Mrs. Sam Goldstein

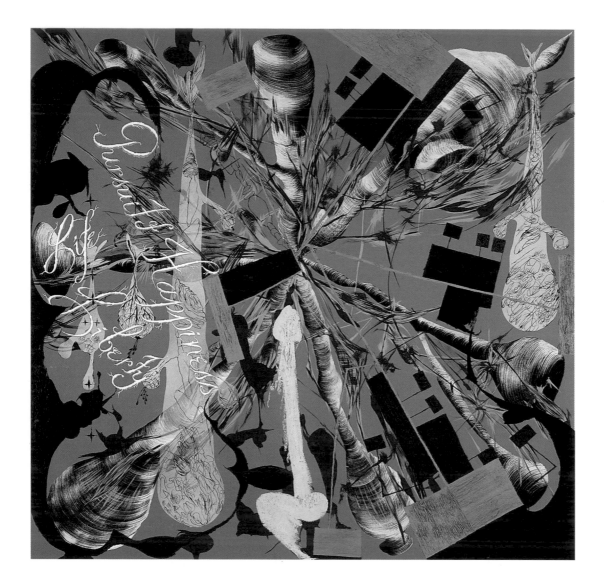

THANKSGIVING
1985
Oil and acrylic on wood panel
80 x 82 in.
Lari Pittman, courtesy of Regen Projects, Los Angeles,
and Jay Gorney Modern Art, New York City

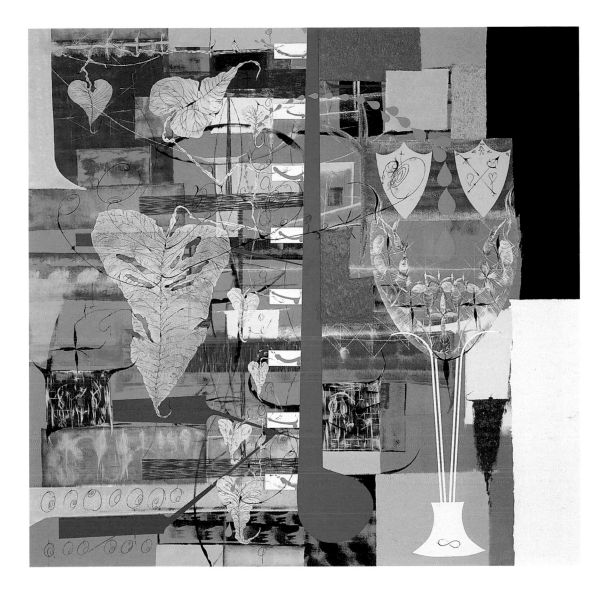

17

END OF THE CENTURY

1986

Oil and acrylic on wood panel

80 x 82 in.

Collection of Phoenix Art Museum,

museum purchase with funds provided by Regina and G. Peter Bidstrup

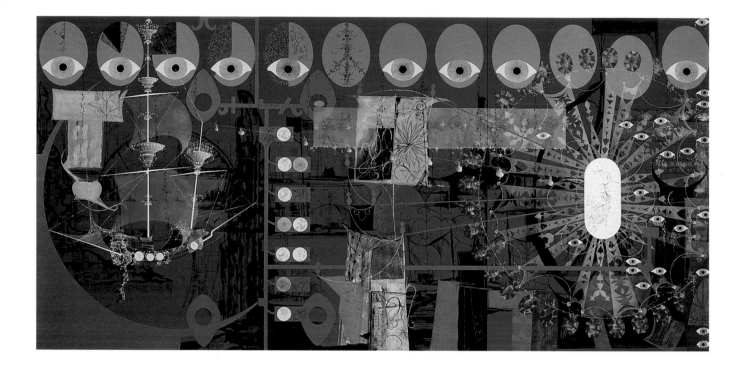

WHERE THE SOUL INTACT WILL SHED ITS SCABS (8624 A.D.)
1987–88
Acrylic on wood panel
96 x 192 in.
The Eli Broad Family Foundation, Santa Monica

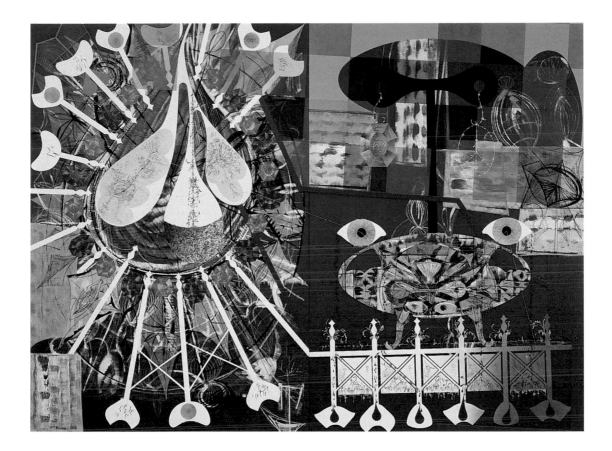

19

WHERE SUFFERING AND REDEMPTION WILL SPROUT FROM THE SAME VINE (7344 A.D.)
1988
Acrylic on wood panel
96 x 128 in.
Mauricio Fernández

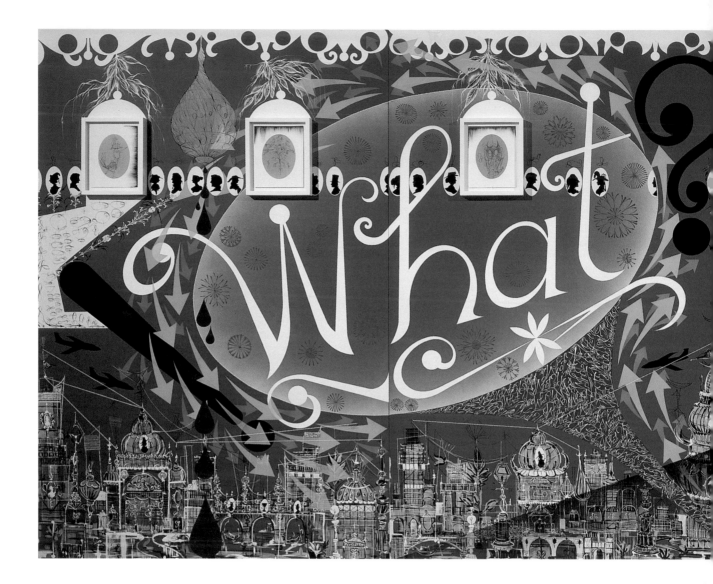

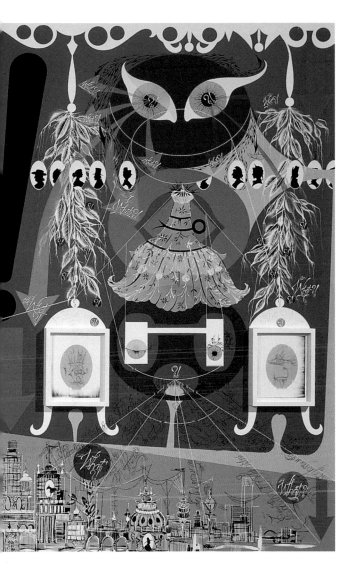

20

HOW SWEET THE DAY, AFTER THIS AND THAT, DEEP SLEEP IS TRULY WELCOMED
1988
Acrylic on wood panel
96 x 192 in.
United Yarn Products Co., Inc., Arthur G. Rosen

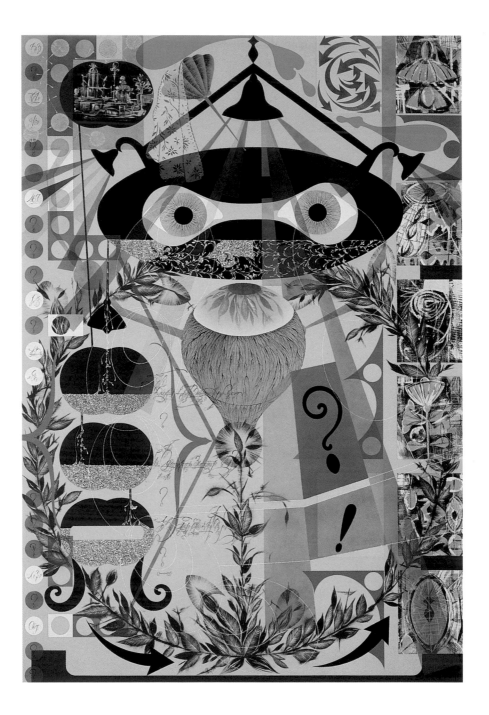

21

THE SOUNDS OF BELIEF, TO AN ATHEIST, ARE VERY TOUCHING

1988

Acrylic on wood panel

96 x 64 in.

Ms. Leslie Lawner

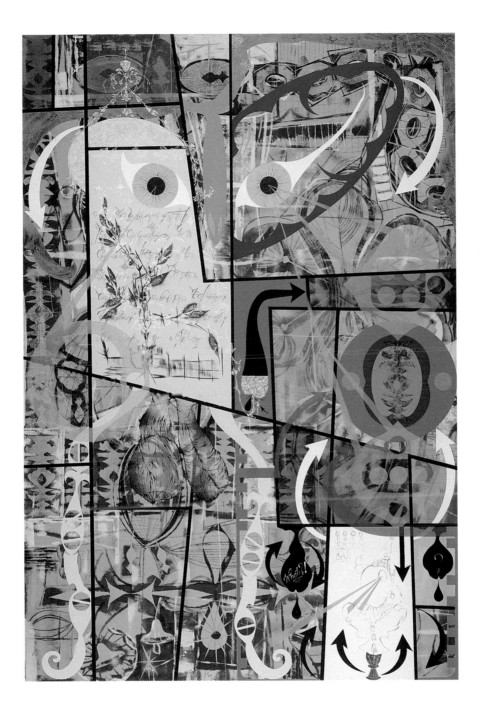

22

FOR NOW INSIDE, LATER TO BE RELEASED UPON MATURATION
1988
Acrylic on wood panel
96 x 64 in.
Lari Pittman, courtesy of Jay Gorney Modern Art, New York City,
and Regen Projects, Los Angeles

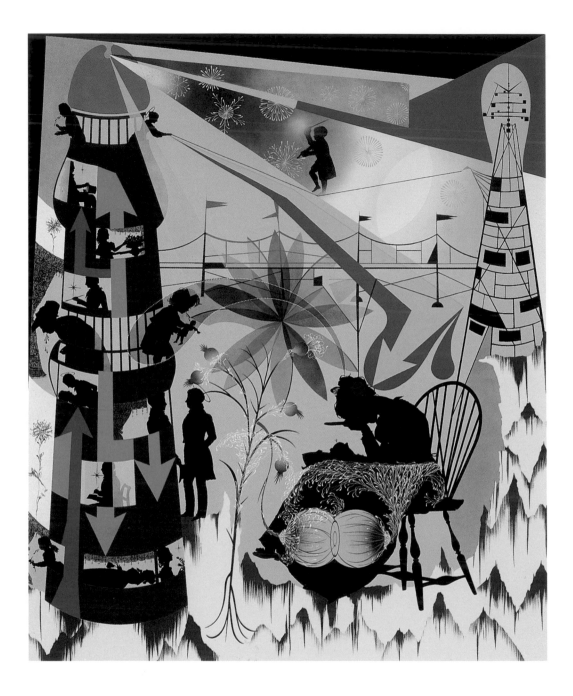

23

THIS DESIRE, BELOVED AND DESPISED, CONTINUES REGARDLESS

1989

Acrylic on wood panel

72 x 60 in.

Clyde and Karen Beswick

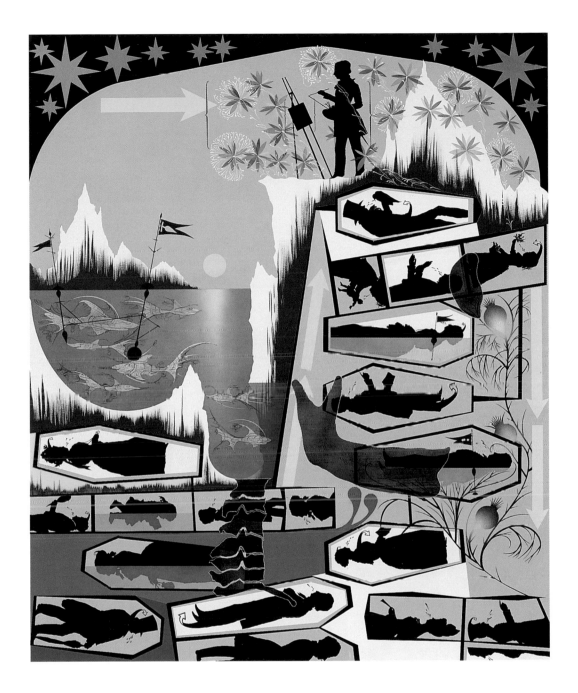

21

THIS LANDSCAPE, BELOVED AND DESPISED, CONTINUES REGARDLESS

1989

Acrylic on wood panel

72 x 60 in.

The John L. Stewart Collection, New York

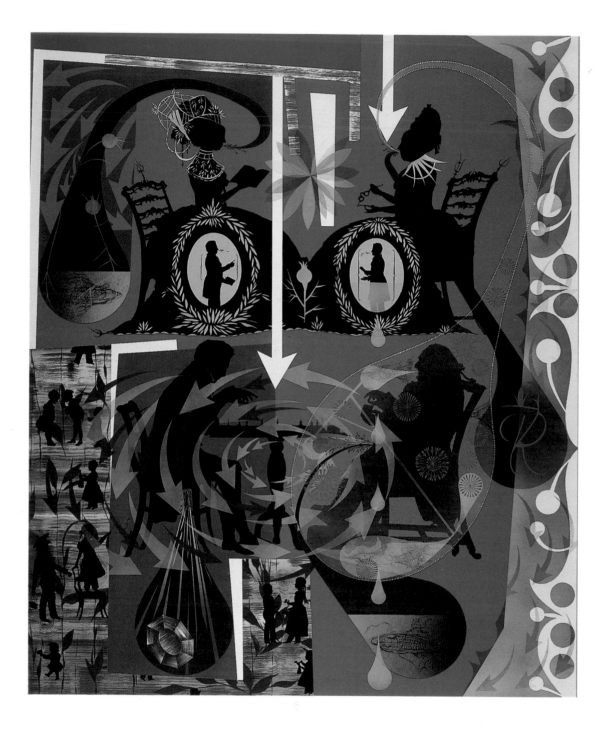

25

THIS DISCUSSION, BELOVED AND DESPISED, CONTINUES REGARDLESS
1989
Acrylic and enamel on wood panel
72 x 60 in.
Collection of Eileen and Peter Norton, Santa Monica

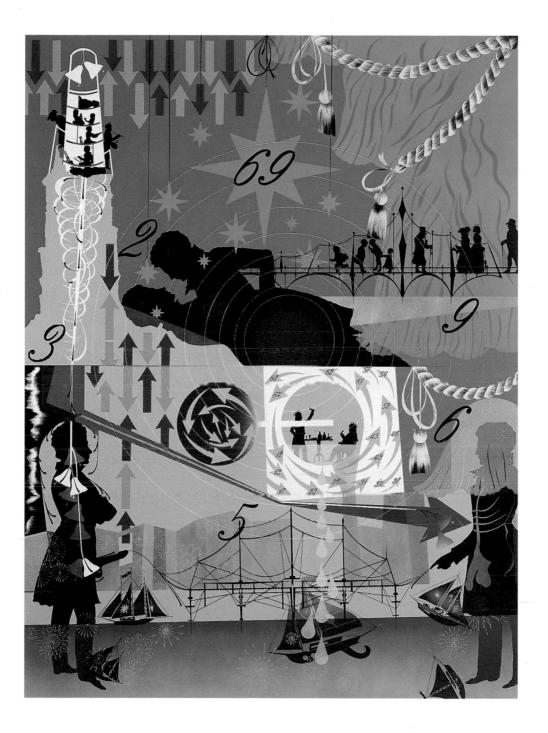

26

THIS WHOLESOMENESS, BELOVED AND DESPISED, CONTINUES REGARDLESS

1990

Acrylic and enamel on wood panel

128 x 96 in.

Los Angeles County Museum of Art, purchased with funds provided by the Ansley I. Graham Trust

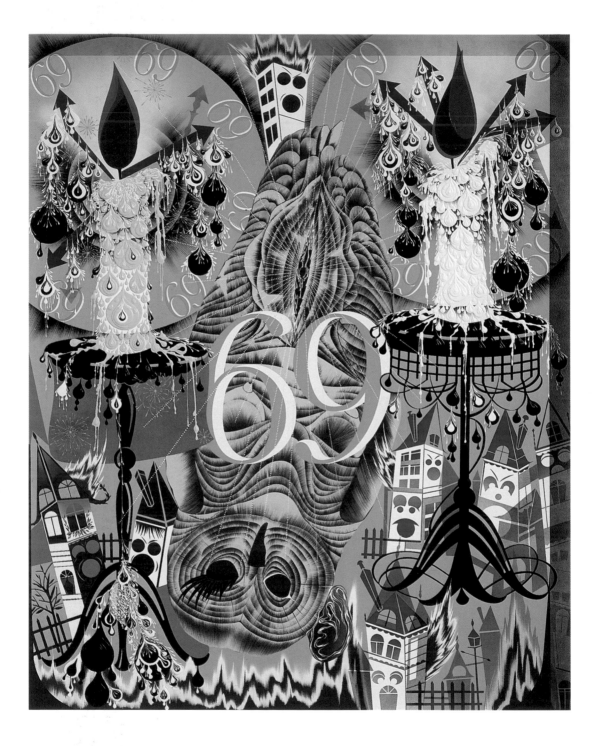

27

TRANSFIGURATIVE AND NEEDY

1991

Acrylic and enamel on wood panel

82 x 66 in.

Gary and Tracy Mezzatesta

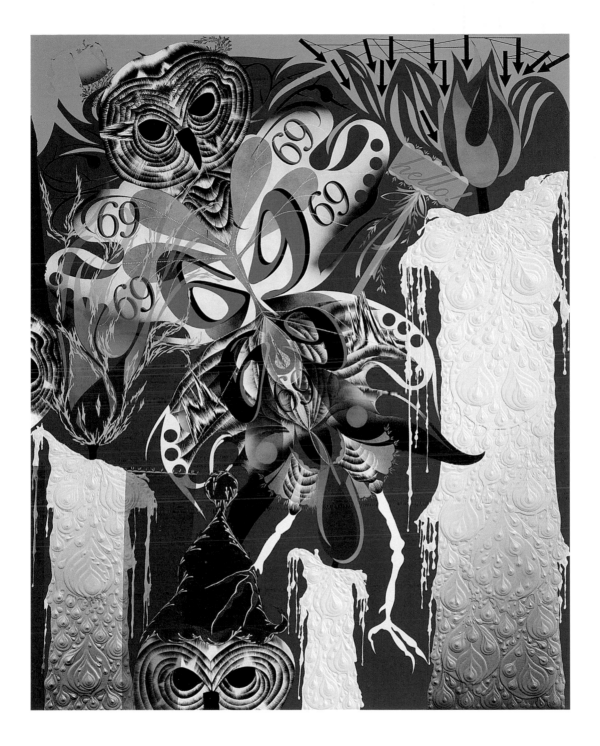

28

MIRACULOUS AND NEEDY

1991

Acrylic and enamel on wood panel

82 x 66 in.

Clyde and Karen Beswick

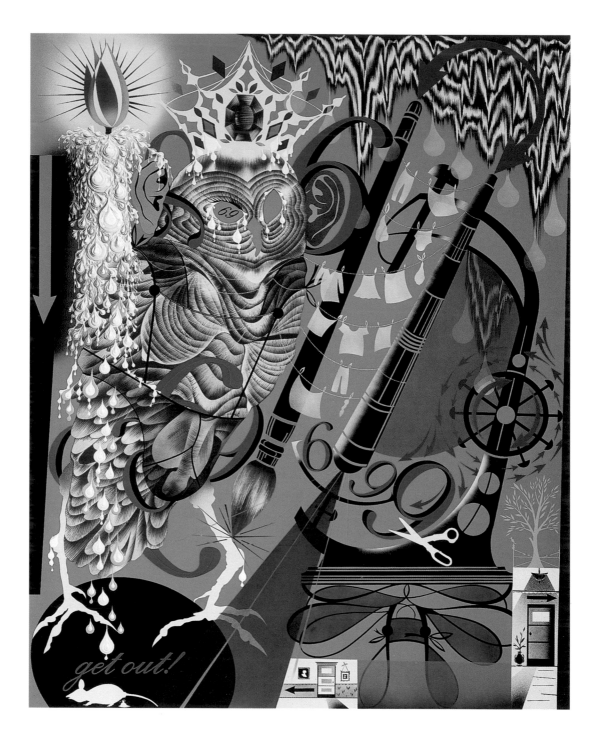

29

TRANSUBSTANTIAL AND NEEDY

1991
Acrylic and enamel on wood panel
82 x 66 in.
United Yarn Products Co., Inc., Arthur G. Rosen

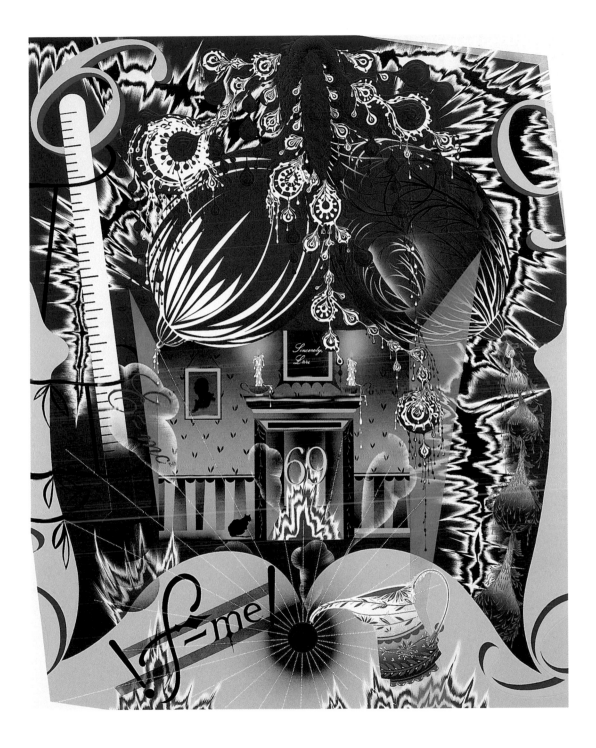

30

SPIRITUAL AND NEEDY
1991—92
Acrylic and enamel on wood panel
82 x 66 in.
Alice and Marvin Kosmin

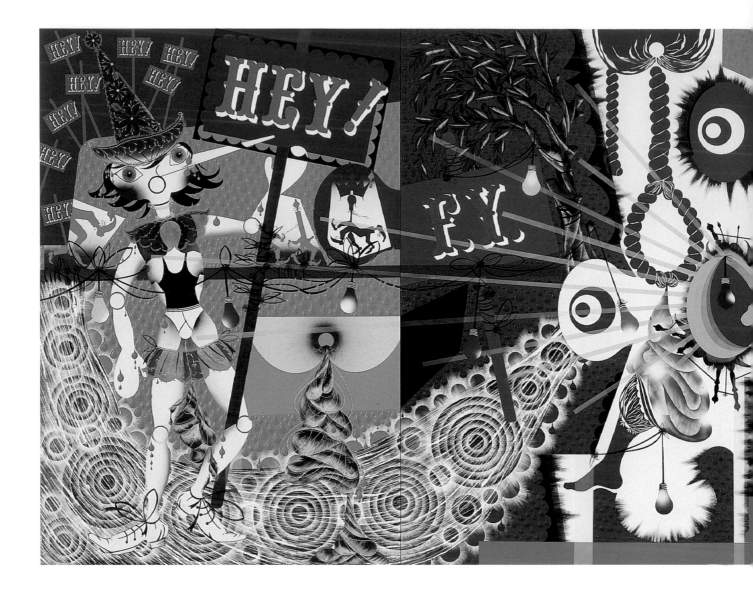

31

A DECORATED CHRONOLOGY OF INSISTENCE AND RESIGNATION #1

1992
Acrylic and enamel on wood panel
96 x 256 in.
Collection Rachel and Jean-Pierre Lehmann

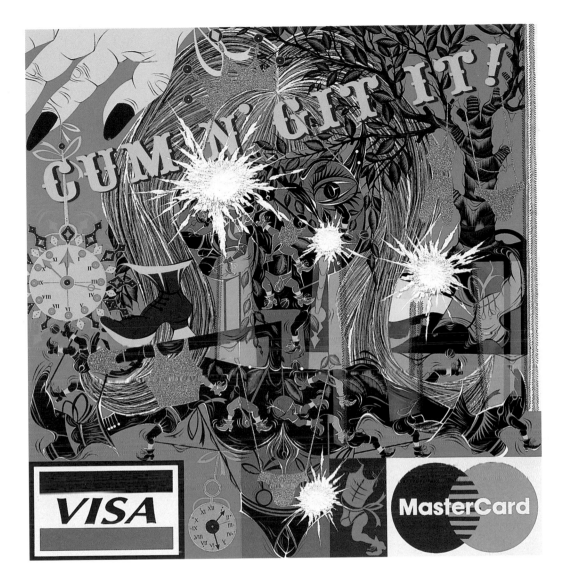

A DECORATED CHRONOLOGY OF INSISTENCE AND RESIGNATION #15

1993

Acrylic, enamel, and glitter on wood panel

83 x 80 in.

Clyde and Karen Beswick

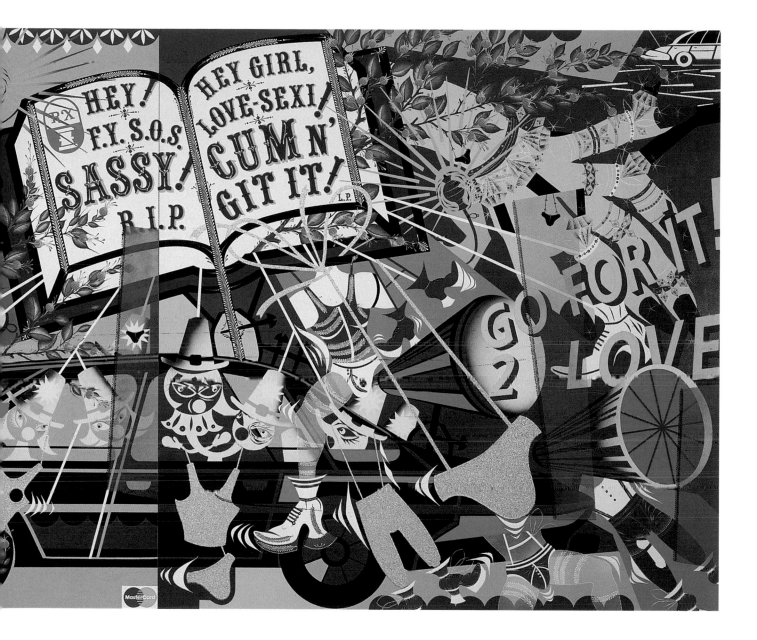

34

A DECORATED CHRONOLOGY OF INSISTENCE AND RESIGNATION #30
1994
Acrylic, enamel, and glitter on wood panel
80 x 164 in.
Private collection

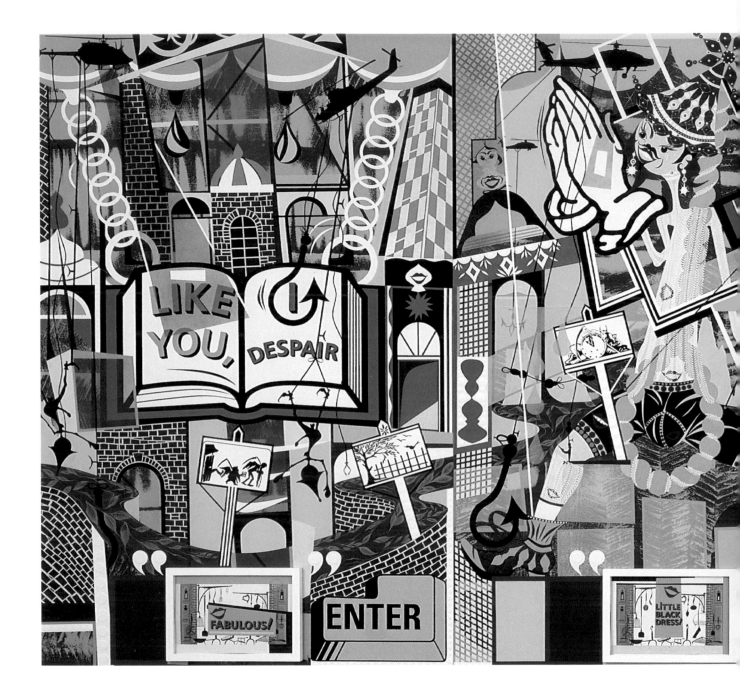

35

LIKE YOU

1995

Acrylic and enamel on wood panel

96 x 312 in.

The Eli Broad Family Foundation, Santa Monica

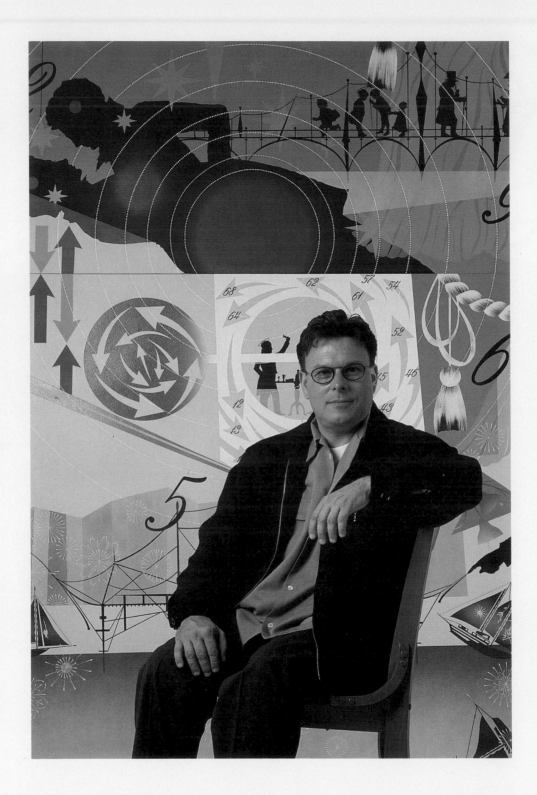

An Interview with
Lari Pittman

PAUL SCHIMMEL

PAUL SCHIMMEL In 1988 we were looking together through the exhibition *CalArts: Skeptical Belief(s)*, organized by the Renaissance Society in Chicago [exploring works by artists who had been affiliated with the California Institute of the Arts], and you noted how displaced your work seemed in relation to artists of your own generation at CalArts and how, somehow in this great machine of conceptual art, you had come out with your own vision.

LARI PITTMAN Well, my work has never had a coolness to it. There's always been this very strong emotional content. And there was a period of time at CalArts when that hyperbolic narrative impulse, where everything is over the top, was antithetical. So, in that sense, I might fit into that generation as a bit of an anomaly. Maybe I'm being a bit delusional, but, if anything, the work fits in with a much younger generation. At the time of *Skeptical Belief(s)* the audience for the work was still to come.

SCHIMMEL You had said that as a painter there really wasn't a place for you, and I commented that Eric Fischl and David Salle were in the show, and you said, "Well, yes, they were there, but painting wasn't." You felt you were the only one still involved with the traditions of painting. You pointed out that even someone like Salle was taking a very conceptual approach.

PITTMAN The driving concept of my work is not something outside of me, but what drives the work is me. Even then I felt very happy with the work, but at the same time I was racked with insecurities: it's too gushy, too sentimentalized, too decorated, too shallow. I think I'm more secure now. A lot of those things which, as a younger artist, I felt were liabilities have actually become my assets.

SCHIMMEL In terms of coming to grips with who you are?

PITTMAN Who I was and then in relationship to what I wanted to put into the history of painting. Everything I wanted wasn't there. At UCLA Lee Mullican was a very insightful teacher for me. He observed that I wasn't happy there and suggested that I apply to CalArts, where his son Matt was studying. I was in the third year of the undergraduate program. Lee said, "I think what you're trying to do in painting will be better received there than here at this point."

SCHIMMEL Which is interesting, because UCLA is known as a painter's school, especially then, not so much today. You had, besides Lee Mullican, the tradition of Richard Diebenkorn.

PITTMAN Another great mentor was Charles Garabedian. Anyway, I think Lee, through his connection with his own son, who was becoming an artist, felt that it would be a better place. In terms of those paint-

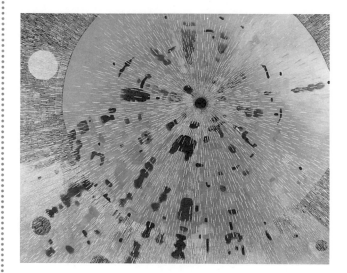

Lee Mullican (United States, b. 1919), *Space*, 1951, oil on canvas, 40 x 50 in., Los Angeles County Museum of Art, partial and promised gift of Fannie and Alan Leslie

ings, even as an undergraduate there was a strong decorative impulse, and Lee knew that at that time there was the pattern and decoration movement and also that the Feminist Art Program was offered at CalArts. There was much more tolerance of such things at CalArts then than later on in the eighties.

SCHIMMEL What do you mean by that?

PITTMAN Well, I think that the history of CalArts has been conveniently rewritten and that it actually excluded a lot of very pivotal people. The whole time that Paul Brach was there was really important for the formation of a lot of artists, including those in *Skeptical Belief(s)*.

SCHIMMEL So the conceptualists have rewritten the history to say this is what it was about.

PITTMAN Exactly.

SCHIMMEL When, in fact, it was a much broader, more catholic program.

PITTMAN Than it became in the mid-eighties. You're almost intimating that as a painter I would have had a problem going to CalArts. I didn't. In fact, I was completely embraced and pushed and prodded all the way by Paul Brach, Miriam Schapiro. I had Elizabeth Murray as a teacher. John Baldessari was always very considerate and helpful. That period of "party line" oppressiveness came later. When I was there, to be a painter was not a problem at all. There weren't many, but your practice was respected.

SCHIMMEL Who were the painters you associated with?

PITTMAN Tom Knechtel, Roy Dowell, Linda Burnham—that was pretty much the core. I hope I'm not forgetting anyone.

SCHIMMEL Why did you go to UCLA in the first place? Are you from here?

PITTMAN I grew up in Colombia and the Los Angeles area. UCLA had a painting department.

SCHIMMEL I meant, why didn't you go to the Rhode Island School of Design or Yale? Why did you stay here?

PITTMAN It was knowing that there was a big art department there. It was also a period of time in the early seventies when you went to college not as a trade school but for a broad, liberal arts education that hardly exists anymore. UCLA represented that broad, sophisticated idea of education and rite of passage.

SCHIMMEL I guess I'm asking why you made the decision not to leave Southern California or Los Angeles. I say this knowing how you've become a strong advocate for the international regionalism of Los Angeles.

PITTMAN I know more in retrospect, of course, than I did at that time, but I had this list of things I wanted my work to do. Then I would look at art history, and I couldn't necessarily make the connection. To make that connection to East Coast culture was even more problematic. It was also a love of popular culture to a certain degree, and that was not being introduced or even entertained as a vocabulary for the making of a painting in most schools. I knew that when I was really young.

SCHIMMEL More instinctively or intuitively?

PITTMAN Instinctively. But consciously too. I felt that something here was different. For example, I knew the whole history of "finish fetish" and a lot of the work coming out of Los Angeles in the sixties and seventies. Then I'd look at what was coming out of New York in the sixties and seventies. Except for pop, which I always loved. But pop almost seems like a blip in the history of New York art to me. It's almost as if New York lost its mind in a good way for the one and only time in its history. Even now when I go to the Museum of Modern Art, I'm aware that my checklist still doesn't match Alfred Barr's. For example, my favorite rooms are what MoMA still thinks of as the "kook rooms"—artists that don't fit in, like Gerald Murphy, Joseph Stella, Florine Stettheimer, Frida Kahlo, Joseph Cornell.

SCHIMMEL The stairways where they put everything that doesn't quite fit.

PITTMAN Even on the "respectable" floors there are a couple of Cornells, but the kook rooms that don't fit that MoMA canon are still pretty much in place. So, I realize how my work can fit in there. I've always been ambitious and have wanted my work to mean something and have ramifications. That's what was great about CalArts. It was the first art school that was not a hippie art school, the first truly contemporary art school in America.

SCHIMMEL Professional.

PITTMAN And also dealing with media and pop culture. It was the only school that even discussed high and low, and low had equal footing with high. That was unusual at that time.

SCHIMMEL In the mid-seventies, from my standpoint working in Texas [at the Contemporary Arts Museum in Houston] and coming out here to California [to the Newport Harbor Art Museum in Newport Beach], one sensed the importance of what the art dealer Holly Solomon was promoting in terms of pattern and decoration. It was very much at the forefront.

PITTMAN Sure. And she was unusual in that way.

SCHIMMEL One can't help but imagine that those artists had an impact upon you at this critical juncture in your life, yet it was a New York-based movement, although Kim MacConnel was out here in La Jolla.

PITTMAN Yes. I was aware of that work and liked it, although there was a certain point when I felt it was just pattern and decoration and not more than that. Even at a very early age, I was dissatisfied with the text upon which that work was based. It remained formal.

SCHIMMEL Visual exercise with no narrative.

PITTMAN In terms of the idea of pattern and text, someone like Elizabeth Murray made much more sense. Or someone who died very young but was very…

SCHIMMEL Ree Morton.

Ree Morton (United States, 1936–77), *Signs of Love*, 1977, installation (1984) at the Hirshhorn Museum and Sculpture Garden, Washington, D.C.

PITTMAN Exactly. She was a feminist and a pioneering installation artist. It's time for a retrospective or a rethinking of her work.

SCHIMMEL She had all the decoration, but there was soul. There was a human being at home.

PITTMAN She was an incredible artist who died very young. So, I was aware of Robert Kushner and MacConnel, but I thought, "Why am I still a bit cold toward it?" Then I saw someone like Ree Morton or Elizabeth Murray, who made sense to me. A person who also chided me a bit was Vija Celmins. She pushed, but she's also interested in pattern and decoration.

SCHIMMEL Certainly pattern. I'm certain she would be a little offended about the decoration part. That's where you come in.

PITTMAN No. I was aware of my connections to pattern and decoration, but at the same time it did leave me a little flat. It was, after all, still about high formalist modernism, even though it was about flowers or whatever. The look of the work seemed different, but the formalist tenets by which it was made were still one and the same thing. It could also have been generational. I wanted to introduce something, and that's why my work changed from levels of abstraction to increased narrative.

SCHIMMEL Which has been the overall growth that the work has moved toward, in an almost evolutionary manner, for a period of almost fifteen years. You started painting in '73, '74, but 1982 was the breakthrough year for you.

PITTMAN I think so.

SCHIMMEL Let's talk about that year. When I first met you, I very much saw the work in the context of things that were happening internationally and also in terms of New York and felt that if you were working there, you would have received the recognition of artists like Carroll Dunham and Terry Winters, who were coming onto the scene and doing organically based abstractions with biomorphic and patterned imagery. Did you feel a connection with those artists?

PITTMAN I think the connection with "Tip" Dunham was certainly there. I don't know about your other

examples. I enjoyed at times Terry Winters or Gary Stephan, but I responded more to the quirkier elements in Dunham's work. Yet, I felt that there was still a fly in the ointment in my own work. So, I don't agree that it would have been so immediately subsumed in the trajectories that you just named and that you're trying to equate me to.

SCHIMMEL Why?

PITTMAN I feel that the work occupied a territory outside of that discussion. If we can talk speculatively here, one doesn't know how that move to New York might have affected the work, but I think there is something very stubborn in me and, in a way, perverse that propels the work forward in such a way that it might always be part of the kook rooms. The work has always carried with it that baggage of eccentricity. This is also how it has been praised.

SCHIMMEL You collect folk art but not "high" art or artists of your age.

PITTMAN As a couple, Roy Dowell and I have collected folk art and contemporary art for twenty years. I'm interested in the idea of the self-taught, the anonymous, the outsider. I always wanted to put something into painting I didn't see there. I had always known of a long, illustrious history of homosexual painters. In very early critiques it was pointed out to me, in a negative way, that some of the things I wanted to put into painting should not be there, because they were considered derogatory or marginal. But I enjoyed that. In a way my work is about reaccording status to that which has been so laughed at and degraded, saying to the viewer, "Well, you tell me what's so wrong with peace and love. It's your job to tell me. Not mine."

SCHIMMEL Is this one of the reasons you collect these nonmainstream, more personalized forms of art?

PITTMAN Yes. It's still fairly new, sadly so, to be openly gay and demand a centrality within the art world as opposed to a marginal position, in which I've never been interested. And I don't mean centrality through assimilation. My work must be accorded a position of criticality, but on my terms. For one to formulate a position that

there is no differentiation between the homosexual artist and the work of art is relatively recent. It is even to this day I hear the worn-out mantra of denial by art world liberals, "Well, we don't care what you do in your private life." I'm not interested in that. I'm interested in what I can do in my public life. That's the main shift. There are endless examples of homosexuals making art, but there are very few examples of homosexual artists who erase that arbitrary distinction between the private and the public, which is something heterosexual artists can do all the time. They are who they are and so is the work they make. I am tired of the sexually neutered histories of Robert Rauschenberg, Jasper Johns, Cy Twombly, and Ellsworth Kelly.

SCHIMMEL What did you think of the 1993 Whitney Biennial, which included numerous artists from "marginalized" groups who attempted to erase that distinction by foregrounding issues of identity?

PITTMAN The problem I had with it was that so many of the artists felt compelled to provide an analogous explanatory voice within the work. Once you do that, I feel you are relegating yourself to marginalization. You need to feel confident enough to put out something really complicated and not necessarily feel that you're being irresponsible by not including the primer by which you understand it. Mathematicians and scientists do this all the time.

SCHIMMEL You never did, did you?

PITTMAN No. That's why to this day people ask what this work is about.

SCHIMMEL Because it's so rich with specific iconographic references, you set up a tension at odds with your stated goal to convey a narrative. Unlike a good religious painting, there is no specific story you can read. So, internal to the painting is a tension.

PITTMAN I think that wanting to "read" a painting in the literal sense is relegating iconographic images to a very one-dimensional function.

SCHIMMEL A literary function.

PITTMAN Yes. It's a surrogate for a specific symbolic meaning. I don't think there's an incorrect way of looking

at the work, although if you were to approach it as if each one of these images equals a particular meaning, then it would take you a little longer to get to the meat. The propensity to look at the paintings, unfortunately, is to always psychologize them. I can understand that, because they're so iconographic, and I have no problem with that. I guess at this point it's really easy to start the discussion with Lari's homosexual work, but it should be just as easy to start a paragraph with Richard Serra's or Chris Burden's heterosexual art. Why doesn't that happen?

SCHIMMEL It's happening more often than you think.

PITTMAN Not in serious criticism. It's a taboo, but it would be very interesting if it could be brought up. The psychologizing of my work in terms of its relationship to my sexuality is fair game for critical analysis and writing. It should also go in the other way.

SCHIMMEL Do you feel any connection with your Latin American roots in your work?

PITTMAN That question has been asked. I have very complicated feelings about that discussion. One of them is that, especially in Southern California and within particular aspects of the art world, Latino identity is not accorded the complexity it deserves. Latino identity is as complex as any other identity, including the hybridization of which I'm a part. In terms of what comes into the work, which feeds a little into what you were saying, is the disparity between the way the work looks and how it invites the viewer to break down the iconography. That also informs the layering process of how the work is actually constructed. Again, this is something that has been clarified as I get older. Half of my family is Anglo-Saxon Presbyterian, and half is Spanish-Italian South American Catholic. As I was growing up, for example, my Colombian grandmother could be tremendously happy, but crying—an idea I didn't perceive in my Anglo-Saxon family.

SCHIMMEL But you did in the Catholic side.

PITTMAN Yes. The whole idea that my grandmother on New Year's Eve would be crying, "Oh, we're all together, but isn't it so sad that we'll be apart tomorrow." I've come to realize that the idea of the bittersweet is at the core of

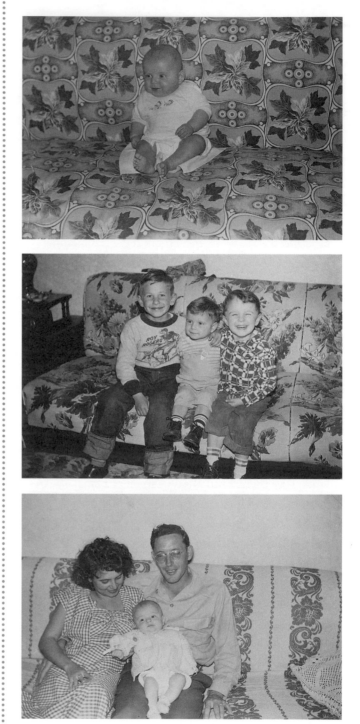

Young Lari with fabric, friends, and family

the construction of simultaneous time, as opposed to the sequential time I perceived more in the Presbyterian, Anglo-Saxon side of the family, which never seemed to cultivate the bittersweet. That's what I'm getting at, in a very elliptical way. When you look at the paintings, it's not confusion that you're looking at, but a simultaneity of events in time. That's the layering in the paintings. It's not about confusion. It's about being able to circumnavigate through the painting, where there is something horrific and really silly, disturbing and very buoyant.

SCHIMMEL Where is your grandmother?

PITTMAN She died a year and a half ago. She was ninety. Her name was Anita Llorente de Rosasco.

SCHIMMEL Did she come here?

PITTMAN Yes, she lived here with my Aunt Leonor.

SCHIMMEL You felt a great closeness to her?

PITTMAN Yes.

SCHIMMEL Of all your relatives?

PITTMAN Well, when I was growing up, I had my Aunt Letty, who was my great aunt. I guess that's the lineage, as she was considered my really eccentric aunt. In those days it was just the unmarried aunt or—what do they call it?—old maid.

SCHIMMEL There's a nicer way of saying it.

PITTMAN This was turn-of-the-century South America. My Aunt Letty was very much my mentor, and she was very eccentric—devoted to her pets. She had pet monkeys, birds, dogs. When I was a child, she took a keen interest in me. I think it was, in a very coded and unspoken way, detecting a lineage of some sort. In my family my eccentricities were never taken away; if anything they were enhanced and pushed. For example, when I was seven or eight years old, I had a pet chicken, Jaime, and we were flying from Cali to Tumaco, where my grandmother's family lived. I remember, because my Aunt Ligia took me to Sears in Cali to buy Jaime. My father asked the pilot if I could carry my pet chicken on my lap. The pilot said, "Sure, no problem." You could do this in South America. I was very concerned that my chicken was well dressed enough, so my grandmother and my Aunt Letty made a complete outfit for it.

SCHIMMEL My advice would eat your heart out, but…

PITTMAN Grandmother and Aunt Letty were both very indulgent. No one made fun of it. It was just my emotional history. They made a jacket, a hat, and these weird shoes, which didn't stay on, because Jaime wanted to claw. It was about an hour-and-a-half flight, and I rode with my father and my mother with my pet chicken on my lap. To me, growing up, that seemed like a completely normal occurrence. That was also very much my Aunt Letty; you know, "Go for it, Lari. Do it. Leave him alone."

SCHIMMEL It's a very charming story, but in a sense, didn't allowing the eccentricities to remain central get…

PITTMAN It's only eccentric from the outside. Within the child's world, whatever they do seems completely like it's supposed to be done. There's no outsider telling them what the parameters are. And in this particular case study, Lari, that eccentricity also happens to be coupled with homosexuality, which is problematic, that fusion of centrality and sexuality. Sexuality for a child is completely central. It only gets dislodged and dislocated during adolescence, and hopefully you can come out of adolescence and say, "No, this is who I am." After you finally find out and say, "OK, adolescence was a nightmare," you start becoming yourself again in your early twenties. It's at that moment, without coincidence, that you start loving your parents again. The fight is over. It's classic in a way.

SCHIMMEL I've always sensed in your work a macabre and dark quality: *Lost at Sea* [1982], *Denatured* [1982], *Shipwrecked* [1982], *Netherworld* [1982; **CATALOGUE 1**], *Maladies and Testaments* [1983; **CATALOGUE 3**], *Host and Parasite* [1983]. These are not happy titles, Lari.

PITTMAN I know. And those were happy days. I think that kind of philosophical rumination has historically been a part of youth. It's charming when you're young, but absolutely embarrassing when you're forty. When you're forty, it's about making sense of your life and making it work.

SCHIMMEL What about the role of decoration in your work?

PITTMAN We confuse issues of decoration. What constitutes decoration and what constitutes decorative-

ness? A large part of the history of minimalism can be discussed, and not necessarily in a pejorative way, as a history of decorative art.

SCHIMMEL It's actually hand-made. The whole design may look machine-made, but, in fact, it's rubbed and polished.

PITTMAN It's obsessive minimalism. It's appropriate and applicable in terms of the decorative, but no one wants to address that. I don't think my work is decorative, because it's ugly. It involves issues of decoration, and decoration is intrinsically conceptual. There's a suspicion in American culture that if it's too painted, it's shallow. If it's too done up, it lacks content. If it's too decorated, it's trying to derail something. In a way minimalism is Shaker, to the extent that it says it is good to be simple and pure. That informs how you view and value minimalism or reduction. So, whenever you present an image that you have dolled or tarted up, an image too colorful, too frosty, or whatever, it's harder for culture to accord it a certain meaning.

SCHIMMEL Exactly. It's not just art, and it's not just a religious experience. It's life.

PITTMAN When I think about the position that decoration has within this culture, I get very stimulated. I like that stimulus, that path of most resistance. The educated art world is positioned to inherit the given discourse about purity, higher moral value, the more spiritual and less materialistic. The rhetoric surrounding minimalism, to this day, is bought lock, stock, and barrel. I'm only interested in decoration and decorativeness if I sense a muscularity.

SCHIMMEL It has to say something.

PITTMAN Yes. And I'm not giving muscularity a gender. I'm just saying that there has to be a skeletal and muscular structure of intent underlying that act of decoration. When I talk about muscularity, I'm interested in extremes. In other words, really butch or really femme. So, I like the ultra-femininity of Florine Stettheimer's work.

SCHIMMEL Because it has this over-the-top quality, which is exactly what you were going for. Stettheimer's

work has irony, while your work still has the basis of great conviction.

PITTMAN In a way, I like it when the work is somewhat ridiculed, because that means I have gone over the top. It brings me a lot of pleasure to see the work operating in a serious, critical world. I like that it has made room for itself. The precedent for affording that critical status to the lineage I'm coming from is not very strong or long. By contrast, if you look at Islamic art, decoration is ideology. I guess what we are talking about is the church of Pittman or the church of Lari. That's why I have "L. P." on the book in *Like You* [1995; **CATALOGUE 35**], the painting I'm currently working on. It's about a reunification of the decorative and the ideological.

SCHIMMEL Your work is also very strident.

PITTMAN Thank you! I like the strident. It's one of the things people have said negatively about the work, and I can understand why. I'm very interested when the work becomes even more than strident, when it becomes shrill, because that's when the eardrums break. I like a certain shrillness.

SCHIMMEL Look at James Ensor's *Entry of Christ into Brussels in 1889*.

PITTMAN That's one of my favorite paintings. What's shocking is that it was made in 1888.

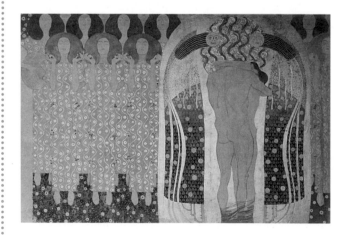

Gustav Klimt (Austria, 1862–1918), *The Beethoven Frieze* (details), 1902, Austrian Gallery, Vienna

SCHIMMEL It takes a jump on expressionism. Your connection with Vienna is why I felt *A Decorated Chronology of Insistence and Resignation #1* [1992; **CATALOGUE 31**], the painting you sent to the show in Vienna [1992], was so spectacular. Vienna is one of the great capitals, with Klimt…

PITTMAN I loved seeing the works of the secessionists.

SCHIMMEL The operatic scale, the cycles of life. Tell me how the shooting affected your work.

PITTMAN *The New Republic* [1985; **CATALOGUE 12**] is a very important painting in that respect. I like this painting, because, for me, it is so clear. Very direct and non-apologetic.

SCHIMMEL I think it marks a breakthrough back into a much more public…

PITTMAN Back into the world.

SCHIMMEL Yet it is one of your most personal works.

PITTMAN I remember I was in the hospital, convalescing from my gunshot injuries, and I said to Roy, "I just thought of something which is very frightening to me. I don't mean to brag in any way, but I realize that I am really tough." That scares me sometimes. I'm accorded this public view as being fussy and a bit of a dandy, but I know that I'm normally really tough. Anyway, when I got shot, I made a vow to myself right then and there that I was not going to faint and I was not going to go under. And I didn't. I don't know if it's something to be proud of or not. I realized that I wasn't going to die, that I was going through a really hard time, but that I wasn't dead. There's that certain point when you're very pragmatic. I'm in the hospital in this horrible pain, but I know that I'm alive and that I'm not going to die. I'll get better eventually. So I began to relax a bit and go over the events, and I think, "Oh, my God, the painting!" It was a really destabilizing moment for me. I had been shot, but that knowledge of this painting in progress, existing with this intestinal imagery, was so destabilizing, because it went so deeply against a strange nonideology I had embraced. Finally, a month later, I got out of the hospital. I came home. I was a physical mess. Absolute physical mess. I had had a colostomy. Then I finally made Roy take me to the studio. I said, "I have to look at that painting." And I remember Roy and a friend of ours propped me up. I was a mess, but I had to look at this painting, because it had completely destabilized me on many levels. And it was uncanny. I thought I would have to call Shirley MacLaine. To this day, I have such a confused relationship with that painting—more detached, but there'll never be any detachment. Yet, there's also a clarity to it which I really…

SCHIMMEL You feel this painting occupies a very important juncture with respect to your move from an inner world to a more social, political, declarative one.

PITTMAN Yes. In a funny way, what you're describing is, for all practical purposes, the trajectory of outing. The imagery is outed. I mean to use that term. You know what it is? I'm not a boy/man anymore. It's the loss of innocence. About this time I start seeing myself as a man, as an adult with a "full-blown" voice.

SCHIMMEL It came at the very moment of your sense of your own mortality, on the heels of this tremendous cataclysm in your life. Regardless of what position you come from, or what politics or sexuality you espouse, you can still address things rigorously and intellectually and philosophically. That's something I see lacking in criticism.

PITTMAN It became liberating for me.

SCHIMMEL And yet clearly, at this time, there was a real distinction between the personal and the public. Let's bring in *An American Place* [1986; **CATALOGUE 14**].

PITTMAN I've never told this to anybody, but the form in the right center is a gun. It's a semiautomatic weapon, an assault weapon. All of these embryonic forms are ejaculating in this moment of violence.

SCHIMMEL Where does the gun come in?

PITTMAN It's hard to recreate how that thought process occurred, but sometimes things are intentionalized from the beginning, and sometimes they are intentionalized during the process of making and evaluating the work.

SCHIMMEL This picket fence is extremely…

PITTMAN It's not a white picket fence, but a black one. So, it's clearly set up to function on a didactic level.

SCHIMMEL It also functions as a counterpart to the work's abstract rhythm. When you work in layers, as you do, how do you end the painting?

PITTMAN One of the things I have a problem with to this day is concluding a painting, tying the knot. This has become a pat answer, but when the painting comes to a full boil, if you go too far, it actually starts canceling itself out. If I continue layering, I could actually start making the surface democratic again.

SCHIMMEL What does that mean?

PITTMAN It could read in a democratic way. Everything is of equal importance. There's no struggle in the work anymore.

SCHIMMEL There's no hierarchy.

PITTMAN Exactly.

SCHIMMEL Almost all of the works have a left side/right side, up/down, good/bad dichotomy. Everything works in terms of dichotomy.

PITTMAN Very much so. An oppositional dynamic. One of the things that has not been discussed about the work as much as I would like are these formal aspects. The work is always very narrative, very symbolic. It alerts the viewer that it's in service of some other idea, but when I look at the works, those that last for me, that are still worth considering, are the ones that have that formal architecture, that structure for the content, that left/right, that up/down.

SCHIMMEL Is it possible that the dichotomy we were talking about is also a formal design?

PITTMAN Absolutely. I don't mean this pejoratively, but I really am a decorator.

SCHIMMEL What's the decorator part?

PITTMAN It's involved in embellishing a very small area, paying attention to the painting's minutiae, because even though they are often very large, they can be read more closely than many large-scale paintings, which usually read only from a distance. For me, it's always been important to allow that intimate reading, while never forgetting the big picture. I'm doing a strand of pearls not across a tiny neck but across the entire painting.

SCHIMMEL Like a string of lights.

PITTMAN Exactly. The history of painting has always been built on chronicling what is already important and significant. For me it's about chronicling, on a broad scale, the overlooked.

SCHIMMEL That which is outside the monumentally historical.

PITTMAN Yes. So, when I use the word *decorator*, it is with a certain irony. It's like taking back language. What is that saying: "Sticks and stones may break my bones, but names will never hurt me"? I'm saying that the decorated, the faggy, the attenuated, the cast off is a great moment to build a practice on. My history as a painter shows that you can build a whole practice of painting on those moments. For example, in *A Decorated Chronology of Insistence and Resignation #1*, you respond very strongly to the figure defecating; a big pile of shit is coming out, but it's decorated. It's entwined with pearls, and it's being granted what it normally wouldn't, a great moment!

SCHIMMEL This painting appeals to me, because it says, "This is what I am." It's decorative art taken to heroic levels—"macho-decorated."

PITTMAN I have to reinvestigate that again. When I left CalArts, I didn't feel much like an artist. Instead of coming out of graduate school and feeling my oats and saying, "Oh, I'm an artist, and I'm going to take the world," I just didn't feel that way.

SCHIMMEL There was no place for you.

PITTMAN It didn't make sense to say, "I'm confident and empowered; therefore, I'll teach," which is what the majority of my colleagues immediately tried to do. I worked in the decorator trade for ten years; I've only been teaching for the last five years.

SCHIMMEL And you're a good teacher.

PITTMAN But I didn't want to teach. I didn't feel confident as an artist, and I didn't feel that there was a place for my work. I enjoyed working in the decorating world. I matured as a person; I learned business.

SCHIMMEL It clearly continues to inform your work. Did you choose the world of decorating because decorative art was closer to your art?

PITTMAN No, not at all. If anything, it was very far

away from the work, because the world I was in, day in and day out, was about incredibly good taste. And my work, to this day, is seen, sometimes incorrectly, to be engaged with bad taste. What the art critic Dave Hickey said about the Liberace Museum really hits it on the head: "Bad taste is real taste, and good taste is the residue of someone else's privilege." So, it was a world I enjoyed, but I was very frustrated at times. I was starting to receive critical attention and sell, but I was still working forty hours per week. That's how I learned to be disciplined about my work. Working forty hours a week for ten years became a way of structuring my life. I remember on my lunch break I would pop over to the gallery and get news like, "Lari, you're going to be in the Whitney Biennial." Then I would have to go back to work immediately, finishing a color scheme for someone's bedroom. Eventually a lot of people from the art world began coming into the shop and would say, "Well, Lari, I just saw your show and found out you're doing this." And I would say, "Absolutely. I do both."

SCHIMMEL You enjoyed the job.

PITTMAN Very much so.

SCHIMMEL You probably stayed there longer than you had to.

PITTMAN I found some comfort in that, ironically, the decorating world doesn't come near the pretensions that the art world entertains. The fabulousness that the art work is always trying to disguise is always being discussed in terms of eternity. In the decorating world, the fabulous is temporary. That made a lot of sense to me.

SCHIMMEL You're often willing to include decorative, debased, sophomoric, popular imagery that makes the viewer uncomfortable.

PITTMAN Yes, like in *Veronica's Veil* [1978], a very early painting I dedicated to Gustav Mahler. As I think back on it, one of the things about his music that still makes sense to me is that there are passages where— even though it's very titanic, very adult, very tortured— he indulges in a high-voltage sentimentality, a noodling of the violin. Instead of the violin being elegant and classical, he gives it a wail. He's usually very rigorous and cerebral, but then he does it "mit Schlag." I like that.

SCHIMMEL You noodle the paintings.

PITTMAN Absolutely. I feel very comfortable with that.

SCHIMMEL Let's talk about *Spiritual and Needy* [1991—92; **CATALOGUE 30**]. The candle, the "69": are they emanating from or entering the ears?

PITTMAN The candle is speaking. The ears are listening. At that period of time, and still to this day, I was not immune to the cultural insecurities surrounding the function of painting. It would be very naive not to acknowledge that painting has an insecure position in our culture, that it is struggling to regain a centrality in critical discussion it hasn't had for a long time. Certainly other practices are now being discussed much more vigorously.

SCHIMMEL Sculptors and installation artists have the high ground now.

PITTMAN And for good reason. But I tried in those works to say that painting lives. That this painting is literally speaking to you. It has a voice. It listens to you. It has ears. You can have sex with it. You can 69 it if you want, literally make it into a complete, sensate toy. Like in *Transfigurative and Needy* [1991; **CATALOGUE 27**], where the owl is upside down, you can actually 69 the owl. It's the idea of making the painting completely active, a willing participant at the viewer's disposal.

SCHIMMEL In all of your works there's "Lari," a personage. But this work is a portrait.

PITTMAN I think so.

SCHIMMEL Usually the portrait of Lari is part of this larger, more complex theatrical scene, but not here.

PITTMAN It's very iconic.

SCHIMMEL Yes, *you* are this figure—the ears, the light. *You* are asking these questions. *You* are making the painting.

PITTMAN But hopefully the viewers superimpose their own meanings onto the image.

SCHIMMEL What's the genesis of *Ennobled and Needy* [1991]?

PITTMAN This painting came at a point when sexual iconography was discussed primarily in terms of the power of the penis. Discussion of the vagina had become

virtually absent. Someone said to me, "Lari, I don't see how, as a male, you could picture a vagina" (many of the works I did at this time pictured vaginas). I said that it's because we only see the vagina as a sexual image. But it's not my object of desire. I'm discussing it as a point of origin where all human beings come from. That was really the whole idea. I was creating, loosely, a town square, but instead of a statue of a hero, there is this wonderful statue of a vagina being celebrated and liberated.

SCHIMMEL What are these two little images within it: one going in, the other going out, one going left, the other going right?

PITTMAN The little inserts are devices to allow the viewer literally to get out of the painting if they choose.

SCHIMMEL You don't look at Lari's pictures; you move through them.

PITTMAN You scan them. If you're fed up with the painting, if it's too oppressive, if it's too much for you, the inserts allow a way out. I use that convention a lot in the work, literally, "GET OUT!"

SCHIMMEL The image of the city square comes back. It's the contrast between the most intimate and the most public: turning the vagina into a public monument. Let's go back to *A Decorated Chronology of Insistence and Resignation #1*.

PITTMAN The Vienna painting. It wasn't the first painting that I did of that series. I was actually into number eight or nine or something.

SCHIMMEL I don't think you've done a better, more important, more confident work in your career than this one. This painting has all the sentimentality, yet it is also accomplished and heroically scaled. I can't think of any other painter who could deal with the theme of the cycles of life in a more clear-minded way. Take me through the picture.

PITTMAN It's a very traditional narrative structure, read from left to right. It's a concise chronology of a person. In the first panel it's "HEY!" In culture a person will say, "Hey," to get attention or initiate something. And then in the second panel it's "F.Y." That could either be "fuck you" or "for you," which is a response. And then you're

angry. Before you know it, you've panicked in the third panel. It's "S.O.S."—"Save Our Souls"—or "Save My Soul." And then before the panic is resolved, you're dead in the fourth panel. It's "R.I.P." But the very smallest sign at the bottom of the painting repeats the cycle with "HEY!" again.

SCHIMMEL The cycle of life.

PITTMAN It's almost set up as a protest. There are picket signs at the beginning and an implied crowd scene. It's about getting the artist's, the public's attention. It goes from insisting on something to resignation: you're dead.

SCHIMMEL But the in-between period is struggle.

PITTMAN It's either "fuck you" or "for you," and then a panic or S.O.S. That's signaled by an image of a torso losing control of its bowels and defecating. But it's not meant as a morbid discussion by any means. That's why it's a "decorated" chronology, which gives it a flip side. Even though it's a discussion of death, it's an ebullient, highly decorated one. In other words, it's not Northern European. It's not Edvard Munch's *The Scream*, where everything is pared down to that moment of profound, howling anxiety. Please, along the way, there is still pleasure.

SCHIMMEL The cycle of life is one of the most traditional Northern European themes, whether you're looking at religious triptychs or Munch.

PITTMAN As I look back on this painting, I still feel that giddiness I felt about making it, about doing something on this scale. And I loved the feeling of exhibiting with that group, with Paul McCarthy, Nancy Rubins, Chris Burden, and Mike Kelley. I see competition as putting your best foot forward. Competition is about bringing the best out in yourself. I don't see it as a negative in any way.

SCHIMMEL A side of you is interested in perversion.

PITTMAN I don't know if I would call it perversion. I think it is a curiosity about all sorts of human expression whether verbal, physical, whatever. Someone said a long time ago that my work has always been politically incorrect. I don't know what that means, but I do use the work as, among other things, a vehicle for me to be reckless. I want to be responsible and a good boy in real life, so I let this four-foot or eight-foot square be a place

where I can depict, not the politically correct world, but the polymorphously perverse one. All human beings have a complex gender identity and a complex identity about sexuality. As an adult you make specific choices, name your object of desire, stick to it, and refine it. That doesn't mean that desire isn't complicated or resolved. I try to allow the paintings to pick up the slack so that the viewer—not that the painting can help actualize a desire—doesn't necessarily have to play out that desire in real life. I'm not saying that the painting is there to escape in—although that's fine also—but that this complexity exists, so just enjoy it.

SCHIMMEL Within those boundaries.

PITTMAN Without guilt. Without the disastrous repercussions that actions in your real life could have.

SCHIMMEL Do you feel you have been more embraced by the homosexual art community because you're gay?

PITTMAN Well, it's interesting. I am. In terms of being granted a position of privilege by the gay community because I'm gay—absolutely. I think it's great!

SCHIMMEL You feel that is the case.

PITTMAN They're a big support structure for my work. Heterosexuals have been backing heterosexuals for years, but no one ever thinks of it that way. No one would ever say that the whole history of heterosexuality is a separatist one.

SCHIMMEL It's more pervasive and less cohesive.

PITTMAN And it's not as deconstructed. I find it interesting that a few homosexuals with some measure of power get more bang for their buck, because their power is seen so clearly as a threat.

SCHIMMEL Do you feel you've embraced that iconographically in your work, that that's made it more aggressive?

PITTMAN I think that there's an anger in me. My attitude is increasingly: "OK, you want to see gay; I'll give you gay." It's with a certain vengeance, but also the sign of a thinking person, the fact that you would be agitated and angry. In a way that has been a fuel for the work.

SCHIMMEL To me *A Decorated Chronology of Insistence and Resignation #1* is a very aggressive painting. You've got this "machine" with these Halloween heads running

through it. You've got it full of cancerous growths.

PITTMAN They're "cum" shots.

SCHIMMEL OK. Good. I was trying to clean it up a little bit. It's a very disturbing, nightmarish painting.

PITTMAN It's lurid.

SCHIMMEL Yes.

PITTMAN How lurid it is but also how fantastically beautiful! That's something I feel a great affinity for. When you look at this painting, it's about the complexity of desire, regardless of the specificity of the person looking at it. I tried to fabricate a "sexiness" with the painting. And that acknowledgment of sexiness is a luridness or distortion. You're still attracted to and repulsed by it at the same time.

SCHIMMEL This hypersexual event is taking place. You have this sort of grandstanding of figures running up here. The totem of masculinity, the bullet shots with the cum shots, the evil and distorted head. It's equating sexuality with purchasing and, therefore, prostitution.

PITTMAN Sex has always been currency, even when money is not exchanged. It's a very powerful currency. There's a revulsion, because every human being would like sex to be beautiful, freely given, and freely accepted anytime, anywhere, by anyone. That would be the optimal world. And clearly one knows it isn't—never has been. For every drop of ebullience and optimism in my work, there is an equal amount of real sadness.

SCHIMMEL Back again to the bittersweet.

PITTMAN Always and forever.

LARI PITTMAN

Born 1952, Glendale, California

Lives in Los Angeles, California

SOLO EXHIBITIONS

1982

Los Angeles Contemporary Exhibitions, Los Angeles. *Sunday Painting: Lari Pittman.* June 9–July 9.

Newport Harbor Art Museum, Newport Beach, California. *New California Artist II: Lari Pittman: Code of Honor.* December 17–January 23, 1983.

1983

Rosamund Felsen Gallery, Los Angeles. January 8–February 5.

1984

Rosamund Felsen Gallery, Los Angeles. September 29–October 27.

1985

Rosamund Felsen Gallery, Los Angeles. November 23–December 21

1987

Rosamund Felsen Gallery, Los Angeles. February 14–March 14.

1988

Rosamund Felsen Gallery, Los Angeles. February 13–March 12.

1989

Rosamund Felsen Gallery, Los Angeles. January 7–February 4.

1990

Rosamund Felsen Gallery, Los Angeles. February 10–March 10.

1991

Rosamund Felsen Gallery, Los Angeles. October 16–November 16.

1992

Jay Gorney Modern Art, New York City. March 7–28.

1993

Jablonka Galerie, Cologne, Germany. *Presentation of: Untitled #1 from the Series: "A Decorated Chronology of Insistence and Resignation."* January 22–February 20.

Mandeville Gallery, University of California, San Diego. *Lari Pittman: Paintings and Works on Paper, 1989–1993.* November 6–December 12.

Rosamund Felsen Gallery, Los Angeles. November 20–December 18.

1994

Jay Gorney Modern Art, New York City. September 17–October 29.

1995

Studio Guenzani, Milan, Italy. January 19–February 28.

Regen Projects, Los Angeles. *Like You.* November 11–December 9.

1996

UCLA at the Armand Hammer Museum of Art and Cultural Center, Los Angeles. *Lari Pittman Drawings.* January 30–March 10. Itinerary: University Art Museum, University of California, Santa Barbara, March 15–April 21. Exhibition catalogue by Elizabeth A. Brown.

GROUP EXHIBITIONS

1976

Long Beach City College Art Gallery, Long Beach, California. *Recent Works: Dowell, Lumbert, Pittman, Sherman.*

1977

Los Angeles Institute of Contemporary Art, Los Angeles. *100 Current Directions in Southern California Art.*

1980

Santa Ana College Art Gallery, Santa Ana, California. *An Exhibition of Drawings: Sandra Jackman, Mary Jones, Tom Knechtel, Lari Pittman, Dara Robinson, Sheila Ruth.* February 20—March 20.

1983

Eaton/Shoen Gallery, San Francisco. *Dealer's Choice: San Francisco/Los Angeles.* May 1—June 11.

Artists' Space, New York City. *Los Angeles/New York Exchange.* May 21—July 2 Itinerary: Los Angeles Contemporary Exhibitions, Los Angeles, June 8—July 9. Exhibition catalogue by Marc Pally and Linda Shearer.

Mandeville Gallery, University of California, San Diego. *Young American Artists II: Paintings and Painted Wall Reliefs.* September 30—October 30.

1984

Fisher Art Gallery, University of Southern California, Los Angeles. *Ceci n'est pas le surrealisme, California: Idioms of Surrealism.* January 20—February 24. Exhibition catalogue edited by Lynn R. Matteson and Jeffrey Yoshimine.

1986

Kuhlenschmidt-Simon Gallery, Los Angeles. *Meanwhile, Back at the Ranch....* April 26—May 17.

1987

Struve Gallery, Chicago. *L.A. Art.* February.

Whitney Museum of American Art, New York City. *1987 Biennial Exhibition.* March 31—June 28. Exhibition catalogue by Richard Armstrong et al.

The Renaissance Society, University of Chicago, Chicago. *Cal Arts: Skeptical Belief(s).* May 6—June 27. Itinerary: Newport Harbor Art Museum, Newport Beach, California, January 24—March 20, 1988. Exhibition catalogue by Catherine Lord et al.

Newport Harbor Art Museum, Newport Beach, California. *Highlights of California Art since 1945: A Collecting Partnership.* May 29—July 26.

Phoenix Art Museum, Phoenix. *1987 Phoenix Biennial.* August 22—October 4. Exhibition catalogue by Bruce Kurtz.

College of Creative Studies, University of California, Santa Barbara. *Lari Pittman: Paintings and Boyd Wright: Sculpture.* September 22—October 16.

MIT-List Visual Arts Center, Cambridge, Massachusetts. *L.A. Hot and Cool: The Eighties.* December 19—February 7, 1988. Exhibition catalogue by Dana Friis-Hansen.

1988

Simon Watson, New York City. *Erotophobia.*

Museum of Contemporary Art, Los Angeles. *Striking Distance.* March 22—May 19. Itinerary: Triton Museum of Art, Santa Clara, California, July 16—August 28; Fresno Arts Center and Museum, Fresno, September 17—October 30; University Art Gallery, Sonoma State University, Rohnert Park, California, November 17—December 16.

Rosamund Felsen Gallery, Los Angeles. *New Works on Paper.* November 19—December 23.

Kresge Art Museum, Michigan State University, East Lansing. *Art of the 1980s: Artists from the Eli Broad Family Foundation Collection.* November 6—December 16. Itinerary: Kalamazoo Institute of Arts, Kalamazoo, Michigan, January 6—February 19, 1989.

Newspace Gallery, Los Angeles. *Los Angeles Organic Abstraction.* November 7—December 3.

1989

Frankfurter Kunstverein im Steinernen Haus and Kunsthalle Schirn am Römerberg, Frankfurt, Germany. *Prospect 89.* March 21—May 21. Exhibition catalogue edited by Martina Detterer et al.

Pence Gallery, Santa Monica. *Victoria.* July 8—September 1.

Pasadena City College Art Gallery, Pasadena, California. *Cultural Fetish.* September 11—October 6.

Museum of Contemporary Art, Los Angeles. *Constructing a History: A Focus on MOCA's Permanent Collection.* November 19—March 4, 1990.

1990

Security Pacific Galleries, Costa Mesa, California. *Representation-Non-Representation.* April 21—June 3. Catalogue.

Galerie Tanja Grunert, Cologne, Germany. *L.A. My Third Lady.* August 3—25.

1991

Simon Watson, New York City. *Something Pithier and More Psychological.* February 23—March 23.

Meyers/Bloom Gallery, Santa Monica, California. *Someone or Somebody.* May 21—June 15.

Museo de Arte Contemporáneo, Monterrey, Mexico. *Mito y magia en América: los ochenta.* June 28—September 23. Exhibition catalogue by Miguel Cervantes et al.

Rosamund Felsen Gallery, Los Angeles. *Quick Coagulation Forms the August Corpse.* August 10—September 7.

Southeastern Center for Contemporary Art, Winston-Salem, North Carolina. *After the Apocalypse: A Different Humanism.* August 24—October 3. Exhibition brochure.

Museum of Contemporary Art, Los Angeles. *Selections from the Permanent Collection, 1975—1991.* August 25—December 15.

Corcoran Gallery of Art, Washington, D.C. *42nd Biennial Exhibition of Contemporary American Painting.* September 7–November 10. Exhibition catalogue by Terrie Sultan.

Randy Alexander Gallery, New York City. *At the End of the Day.* December 3–21.

1992

Museum of Contemporary Art, Los Angeles. *Helter Skelter: L.A. Art in the 1990s.* January 26–April 26. Exhibition catalogue by Paul Schimmel et al.

Studio Guenzani, Milan, Italy. *Paul McCarthy, Lari Pittman, Jeffrey Vallance.* March 31–May 15.

Postmasters Gallery, New York City. *Masquerade (Body Double).* May 2–30.

Museum of Contemporary Art, Los Angeles. *Selections from the Permanent Collection.* June 7–August 23.

Roy Boyd Gallery, Santa Monica, California. *In Pursuit of Devoted Repulsion.* June 13–July 25.

Arthur Roger Gallery, New York City. *Fear of Painting.* September 8–October 3. Catalogue by Dan Cameron.

Castello di Rivara, Torino, Italy. *Viaggio a Los Angeles.* September 19–November 1.

Galerie Krinzinger, Vienna, Austria. *Lari Pittman Paintings [LAX] 1992.* November 4–December 22.

1993

Patricia Shea Gallery, Los Angeles. *Appraising the Preternatural.* January 21–February 27.

John Berggruen Gallery, San Francisco. *Daylight Savings: Richmond Burton, Robert Kusher, Lari Pittman, Alexis Rockman.* February 10–March 6.

Whitney Museum of American Art, New York City. *1993 Biennial Exhibition.* February 24–June 20. Exhibition catalogue by Elizabeth Sussman.

Krannert Art Museum and Kinkead Pavilion, University of Illinois, Champaign. *Paper Trails: The Eidetic Image: Contemporary American Work on Paper.* March 17–April 18.

Americas Society, New York City. *Space of Time: Contemporary Art from the Americas.* September 24–January 2, 1994. Itinerary: Center for the Fine Arts, Miami, Florida, June 1–August 20, 1995. Exhibition catalogue by Sandra Antelo-Suarez et al.

Rhona Hoffman Gallery, Chicago. *Legend in My Living Room.* October 22–December 24.

The Drawing Center, New York City. *The Return of the Cadavre Exquis.* November 6–December 18. Exhibition catalogue by Ingrid Schaffner et al.

Museum of Contemporary Art, Los Angeles. *Altered States: Selections from the Permanent Collection.* December 19–February 6, 1994.

1994

James Corcoran Gallery, Santa Monica, California. *Animal Farm.* January 15–February 16.

Thread Waxing Space, New York City. *Don't Look Now.* January 22–February 26.

P.P.O.W., New York City. *Arabesque.* February 18–March 19.

Long Beach Museum of Art, Long Beach, California. *Love in the Ruins.* March 4–May 22. Exhibition catalogue by Noriko Gamblin.

Museum of Contemporary Art, Los Angeles. *Interiors: Some Work from the Permanent Collection.* April 24–June 19.

UCLA at the Armand Hammer Museum of Art and Cultural Center, Los Angeles. *The Assertive Image: Artists of the Eighties from the Eli Broad Family Foundation.* June 7–October 9. Exhibition catalogue [by Elizabeth Shepherd].

Rosamund Felsen Gallery, Los Angeles. *In Retrospect: Paintings of the '80s.* August 13–September 3.

1995

University Art Museum, University of California, Berkeley. *In a Different Light: Visual Culture, Sexual Identity, Queer Practice.* January 11–April 9. Exhibition catalogue edited by Nayland Blake et al.

Neue Galerie am Landesmuseum Joanneum, Graz, Austria. *Pittura Immedia: Malerei in den 90er Jahren.* March 11–April 18. Exhibition catalogue by Peter Weibel and Thomas Dreher.

Whitney Museum of American Art, New York City. *1995 Biennial Exhibition.* March 23–June 4. Exhibition catalogue by Klaus Kertess.

Museum of Contemporary Art, Los Angeles. *Cycles, Strategies, Dialogues: Works from the 1980s in the Permanent Collection.* July 9–October 15.

Jay Gorney Modern Art, New York City. *Carroll Dunham/Lari Pittman.* September 16–October 14.

Manny Silverman Gallery, Los Angeles. *Painting beyond the Idea.* September 16–October 28. Exhibition catalogue by Terry R. Myers.

Soros Center for Contemporary Arts, Ljubljana, Slovenia. *Stereo-tip.* October. Exhibition catalogue by Helena Pivec et al.

1996

Grossman Gallery, School of the Museum of Fine Arts, Boston. *Social Functions: Lari Pittman and Andrea Zittel.* February 21–March 17. Exhibition catalogue by Leila Amalfitano.

Selected Bibliography

1983

Wilson, William. "The Galleries." *Los Angeles Times*, 14 January, "Calendar," 9. Exhibition review.

Knechtel, Tom. "A Wistful Angst." *Artweek*, 22 January, 7.

Larsen, Susan C. "Lari Pittman." *Artforum* 21 (May): 104. Exhibition review.

Curtis, Cathy. "Up from the South." *Artweek*, 28 May, 16.

Albright, Thomas. "L.A. Artists in an Exchange Show Here." *San Francisco Chronicle*, 30 May, 37. Exhibition review.

Howe, Katherine. "Los Angeles-New York Exchange." *Images & Issues* 4 (November–December): 56–57.

1984

Baitz, Jon Robin. "Art: The Mexican Connection." *The Reader* (Los Angeles), 18 May, 1, 6.

Pincus, Robert L. "The Galleries." *Los Angeles Times*, 5 October, "Calendar," 12. Exhibition review.

Gardner, Colin. "Art in Los Angeles." *The Reader* (Los Angeles), 26 October, 13. Exhibition review.

1985

Gardner, Colin. "Lari Pittman." *Flash Art*, no. 120 (January): 46–47. Exhibition review.

Mallinson, Constance. "Lari Pittman at Rosamund Felsen." *Art in America* 73 (February): 144, 147. Exhibition review.

Muchnic, Suzanne. "The Art Galleries." *Los Angeles Times*, 29 November, "Calendar," 16. Exhibition review.

Knight, Christopher. "Pittman's Newest Work—Radical." *Los Angeles Herald Examiner*, 8 December, E-6. Exhibition review.

Gipe, Lawrence. "Pick of the Week." *L.A. Weekly*, 13 December, 125. Exhibition review.

Cooper, Bernard. "Parts That Speak of a Whole." *Artweek*, 14 December, 6. Exhibition review.

1986

Drohojowska, Hunter. "Lari Pittman." *Art News* 85 (February): 105. Exhibition review.

Gardner, Colin. "Lari Pittman." *Artforum* 24 (April): 116. Exhibition review.

Pincus, Robert L. "Paintings of Lari Pittman Are Multi-faceted, Engaging." *San Diego Union*, 2 October, D-10. Exhibition review.

McDonald, Robert. "Pittman Proves the Ugly Can Offer Fascination." *Los Angeles Times* (San Diego edition), 21 October, "Calendar," 1–2. Exhibition review.

1987

Gipe, Lawrence. "Against Irony," *L.A. Weekly*, 13 February, 49.

Wilson, William. "The Art Galleries." *Los Angeles Times*, 20 February, section 6, 16. Exhibition review.

Knight, Christopher. "L.A. Art Star Has a Stroke of Ingenious Reinvention." *Los Angeles Herald Examiner*, 22 February, E-1, E-6.

Brenson, Michael. "Art: Whitney Biennial's New Look." *New York Times*, 10 April, C-24. Exhibition review.

Wolff, Theodore F. "Fun, Flashy and Fashionable." *Christian Science Monitor*, 16 April, 22–23.

Knight, Christopher. "Whitney Show Reflects Calm after the Storm." *Los Angeles Herald Examiner*, 19 April, E-2. Exhibition review.

Cotter, Holland. "Eight Artists Interviewed." *Art in America* 75 (May): 162–79.

1988

Knight, Christopher. "Majestic Mementos." *Los Angeles Herald Examiner*, 19 February, "Weekend," 8. Exhibition review.

Muchnic, Suzanne. "The Galleries." *Los Angeles Times*, 19 February, "Calendar," 17. Exhibition review.

Pincus, Robert L. "Cal Arts Alumni Show Skeptical Beliefs in Variety of Ways." *San Diego Union*, 28 February, E-10. Exhibition review.

Flam, Jack. "L.A.'s Growing Art Scene." *Wall Street Journal*, 9 March, 24.

Gardner, Colin. "CalArts: Skeptical Belief(s)." *Artforum* 26 (April): 154. Exhibition review.

Leigh, Christian. "L.A. Hot and Cool—the Eighties." *Artforum* 26 (April): 150–51. Exhibition review.

Muchnic, Suzanne. "Cohesive Show Looks at Life from 'Distance.'" *Los Angeles Times*, 27 April, "Calendar," 5. Exhibition review.

Clothier, Peter. "Lari Pittman." *Artnews* 87 (September): 172–73. Exhibition review.

Fehlau, Fred. "Lari Pittman: A Close Reading." *Visions* 3 (winter): 18–19.

1989
Kelley, Mike. "Foul Perfection: Thoughts on Caricature." *Artforum* 27 (January): 92–99.

Curtis, Cathy. "The Galleries." *Los Angeles Times*, 13 January, section 6, 20. Exhibition review.

Kandel, Susan. "Pick of the Week." *L.A. Weekly*, 27 January, 147.

Knight, Christopher. "Pittman Paints in His Own Language." *Los Angeles Herald Examiner*, 27 January, "Weekend," 7. Exhibition review.

Gerstler, Amy. "Lari Pittman." *Artforum* 27 (March): 143–44. Exhibition review.

Fehlau, Fred. "Lari Pittman." *Flash Art*, no. 145 (March–April): 117. Exhibition review.

Kandel, Susan. "Lari Pittman." *Arts* 63 (April): 109. Exhibition review.

Weissman, Benjamin. "Lari Pittman." *Art Issues*, no. 4 (May): 25. Exhibition review.

Curtis, Cathy. "The Galleries." *Los Angeles Times*, 18 August, section 6, 16. Exhibition review.

1990
Geer, Suvan. "The Galleries." *Los Angeles Times*, 16 February, F-27. Exhibition review.

Snow, Shauna. "Lari Pittman: Breathing Life into His Art." *Los Angeles Times*, 4 March, "Calendar," 91.

Carlson, Lance. "Lari Pittman." *New Art Examiner* 17 (April): 49–50. Exhibition review.

Britton, Donald. "Cover: Lari Pittman." *Art Issues*, no. 11 (May): cover, 36.

Scarborough, James. "Carving Out a Niche." *Artweek*, 17 May, 10–11. Exhibition review.

Selwyn, Marc. "Lari Pittman." *Flash Art*, no. 152 (May–June): 158. Exhibition review.

1991
Pagel, David. "Art Reviews: A Thrill a Minute." *Los Angeles Times*, 7 November, F-7. Exhibition review.

Weissman, Benjamin. "Lari Pittman." *Artforum* 30 (December): 109–10. Exhibition review.

Pagel, David. "Lari Pittman." *Bomb*, no. 34 (winter): 48–53. Interview.

1992
Zellen, Jody. "Lari Pittman." *Arts* 66 (January): 73. Exhibition review.

Muchnic, Suzanne. "Art in the City of Angels and Demons." *Los Angeles Times*, 26 January, "Calendar," 4–5, 76–78.

Rugoff, Ralph. "Apocalypse Noir: MOCA's Helter Skelter and the Art of Our Times." *L.A. Weekly*, 31 January, 18–20, 22–25. Exhibition review.

Knight, Christopher. "An Art of Darkness at MOCA." *Los Angeles Times*, 28 January, F-1, F-4–5. Exhibition review.

Pagel, David. "Lari Pittman." *Flash Art*, no. 162 (January–February): 134. Exhibition review.

Clothier, Peter. "Lari Pittman." *Artnews* 91 (February): 136. Exhibition review.

Carlson, Lance. "Darkness and Light." *Artweek*, 19 March, 1, 9. Exhibition review.

Merrill, R. J. "A Conversation with Lari Pittman." *Artweek*, 19 March, 10.

Smith, Roberta. "Lari Pittman." *New York Times*, 27 March, C-9. Exhibition review.

Kandel, Susan. "L.A. in Review." *Arts* 66 (April): 98–100. Exhibition review.

Bonami, Francesco. "U.S. Pain: New American Figuration." *Flash Art*, no. 164 (May–June): 100–102.

Adams, Brooks. "Lari Pittman at Jay Gorney." *Art in America* 80 (September): 123. Exhibition review.

Cameron, Dan. "Sweet Thing." *Artforum* 31 (December): 58–59.

Cooper, Dennis, and C. Yancy. "Lari Pittman: The August Vigilante." *Artforum* 31 (December): 54–57.

1993
Smith, Roberta. "At the Whitney: A Biennial with a Social Conscience." *New York Times*, 5 March, C-1, C-27. Exhibition review.

Knight, Christopher. "Crushed by Its Good Intentions." *Los Angeles Times*, 10 March, F-1, F-8–9. Exhibition review.

Schjeldahl, Peter. "Art + Politics = Biennial: Missing the Pleasure Principle." *Village Voice*, 16 March, 34, 38. Exhibition review.

Duncan, Michael. "Report from Los Angeles: 'LAX' Lifts Off." *Art in America* 81 (April): 50–55.

Schor, Mira. "Course Proposal." M/E/A/N/I/N/G, no. 13 (May): 20–23.

Rian, Jeff. "The 1993 Whitney Biennial: Everyone Loves a Fire." *Flash Art*, no. 170 (May–June): 78–79. Exhibition review.

Malen, Lenore. "Postscript: An Anal Universe." *Art Journal* 52 (fall): 79–81.

Muchnic, Suzanne. "Fast Forward: Lari Pittman." *Artnews* 92 (November): 125.

Kimmelman, Michael. "The Exquisite Corpse Rises from the Dead." *New York Times*, 7 November, section 2, 41.

Pincus, Robert L. "Pittman as Bright as Ever." *San Diego Union-Tribune*, 28 November, E-1, E-5. Exhibition review.

Drohojowska-Philp, Hunter. "The Pleasure Posture." *Art Issues*, no. 30 (November–December): 20–23.

Pagel, David. "A Visit to the Hyperactive World of Lari Pittman." *Los Angeles Times*, 4 December, F-2, F-4. Exhibition review.

1994

Schaffner, Ingrid. "Cursive/Das Kursive." *Parkett*, no. 42, 114—22.

Smith, Roberta. "Group Shows of Every Kind, Even Where the Show Itself Is an Art Form: P.P.O.W.." *New York Times*, 25 February, c-22. Exhibition review.

Knight, Christopher. "A Suggestion of Cultural Edginess." *Los Angeles Times*, 10 March, F-1, F-11.

Duncan, Michael. "Lari Pittman." *Flash Art*, no. 175 (March—April): 108—9. Exhibition review.

Brooks, Rosetta. "'Love in the Ruins.'" *Artforum* 32 (May): 107. Exhibition review.

Pagel, David. "Cultivating Unexpected Vistas of Artificial Landscapes." *Los Angeles Times*, 18 August, F 4. Exhibition review.

Myers, Terry R. "In the Galleries: Lari Pittman at Jay Gorney." *Art & Auction* 17 (September): 52. Exhibition review.

Cotter, Holland. "Lari Pittman." *New York Times*, 30 September, c-31. Exhibition review.

Scarborough, James. "Los Angeles: Lisa Adams, Lari Pittman." *Art Press* (Paris), no. 196 (November): II—III. Exhibition review.

Myers, Terry R. "Painting Camp: The Subculture of Painting, the Mainstream of Decoration." *Flash Art*, no. 179 (November—December): 73—75.

Duncan, Michael. "L.A. Rising." *Art in America* 82 (December): 72—83.

Gardner, Paul. "Light, Canvas, Action! When Artists Go to the Movies." *Artnews* 93 (December): 124—29.

1995

Jones, Amelia. "Lari Pittman's Queer Feminism." *Art + Text* (Sydney, Australia), no. 50 (January): 36—42.

Bonetti, David. "San Francisco Show and Tell." *Out*, no. 21 (April): 52.

Knight, Christopher. "Toning it Down at the Whitney." *Los Angeles Times*, 16 April, "Calendar," 5, 54.

Johnson, Ken. "Report from New York: Big Top Whitney." *Art in America* 83 (June): 40—43. Exhibition review.

Avgikos, Jan. "1995 Biennial, Whitney Museum of American Art." *Artforum* 33 (summer): 100—101, 136. Exhibition review.

Karmel, Pepe. "Anything Goes—As Long As It's Not Boring." *ArtNews* 94 (September): 126—29.

Schmerler, Sarah. "Carroll Dunham and Lari Pittman." *Time Out/New York*, 11—18 October, 29.

Kandel, Susan. "Lari Pittman's Bucolic, Bizarre Paintings." *Los Angeles Times*, 17 November, F-20. Exhibition review.

1996

Gleason, Mat. "Cover Story: Lari Pittman." *Coagula Art Review*, no. 21: 38—39.

Greene, David A. "Lari Pittman's Like You." *Art Issues*, no. 41 (January February): 48. Exhibition review.

Knight, Christopher. "Faces to Watch in '96: Lari Pittman." *Los Angeles Times*, 7 January, "Calendar," 9.

Wilson, William. "The Decadent Decor of Pittman's 'Drawings.'" *Los Angeles Times*, 7 February, F-1, F-5. Exhibition review.
Wachs, Joel. "Letters: Pittman's Eloquent Voice." *Los Angeles Times*, 17 February, F-16. Reader response to exhibition review of 7 February.
Burnham, Linda, et al. "Counterpunch: Review of 'Drawings' Draws Anger." *Los Angeles Times*, 26 February, F-3. Reader responses to exhibition review of 7 February. Graham, Robert, et al. "Counterpunch: Pittman's Art Should Stand, Fail on Own Merits." *Los Angeles Times*, 4 March, F-3. Reader responses to exhibition review of 7 February.

Darling, Michael. "Nothing's Shocking." *Los Angeles Reader*, 23 February, 11. Exhibition review..

Acknowledgments

HOWARD N. FOX
Curator of Contemporary Art
Los Angeles County Museum of Art

Virtually all departments of the Los Angeles County Museum of Art contributed to the development of this show. My friend and colleague Stephanie Barron, senior curator of twentieth-century art and coordinator of curatorial affairs at the museum, was instrumental in the realization of this project; I deeply appreciate her official and personal support of the exhibition and this catalogue. Leslie Bowman, assistant director/exhibitions, the late John Passi, and Beverley Sabo assisted in making this show available to the participating venues. In the development office Tom Jacobson, head of grants, and his assistant, Stephanie Dyas, coordinated the grant applications that ultimately helped fund the project. Registrar Renee Montgomery and Jennifer Weber, assistant registrar, had the formidable job of gathering the contents of the show together from its international sources and then sending it back out on the road. The installation of the show in Los Angeles was coordinated by Art Owens, assistant director/operations, and Tim Anderson, supervising preparator. Brent Saville brought his genius for spatial organization to the design of the installation. To all of these individuals and the people who worked so closely with them—especially my assistant, Nina Berson, who handled myriad details of all aspects of the production—I extend my warmest gratitude and thanks.

This exhibition benefited from a grant from the National Endowment for the Arts, a federal agency. As a citizen I am grateful for federal patronage of the arts, and as the organizer of this exhibition I am thankful for the NEA grant that was awarded. The Lannan Foundation and the Peter Norton Family Foundation also provided generous support for this undertaking. Without their combined assistance this exhibition and its tour could not have taken place.

It is a privilege to have enjoyed the participation of two other distinguished museums in offering this exhibition to a broader public. At the Contemporary Arts Museum in Houston, director Marti Mayo and curator Dana Friis-Hansen were enthusiastic about bringing the project there. Terrie Sultan, curator of contemporary art at the Corcoran Gallery of Art in Washington, D.C., was an early and ardent advocate of the exhibition, and we are all pleased that the show will be seen in the nation's capital. I am confident that these individuals have served their institutions and their audiences well.

This catalogue is an integral aspect of the presentation and, in fact, took as much effort and cooperation to produce as the exhibition itself. This publication has been greatly enriched by the extremely insightful essay by Dave Hickey, associate professor of art criticism and theory at the University of Nevada, Las Vegas; and by a most engaging interview with the artist which was conducted by Paul Schimmel, chief curator at the Museum of Contemporary Art, Los Angeles. Paul was prescient in his recognition of Lari Pittman and was the first curator to organize a museum exhibition of Pittman's art, at the Newport Harbor Art Museum way back in 1982. The intrepid Roz Leader, who has valiantly served many research projects at the Los Angeles County Museum of Art, compiled the bibliography and exhibition history. I thank them all for their contributions. The lively design of this book is the creation of Jim Drobka, and its astute editing is the product of Mitch Tuchman, who (almost) always has the last word.

To the many kind and enthusiastic individuals and institutions who lent their works of art to this presentation the best thanks I can offer is the exhibition that they have enabled to come to fruition. I hope they may be as gratified to have parted with their works for so long as we can all be that they have agreed to do so.

Finally I wish to thank Lari Pittman for his good cheer, his endless goodwill, and his excellent, challenging, and uplifting art. It took me a while to come to his art; I am pleased to have the opportunity to bring it to the museum.

Lenders to the Exhibition

Sula Fay Bermúdez-Silverman

Clyde and Karen Beswick

The Eli Broad Family Foundation, Santa Monica

The Carnegie Museum of Art, Pittsburgh

Collection of Douglas S. Cramer

Rosamund Felsen

Mauricio Fernández

Jay Gorney Modern Art, New York City

Mike Kelley

Alice and Marvin Kosmin

Ms. Leslie Lawner

Collection Rachel and Jean-Pierre Lehmann

Los Angeles County Museum of Art

Gary and Tracy Mezzatesta

The Museum of Contemporary Art, Los Angeles

The Newport Harbor Art Museum, California

Merry Norris

Collection of Eileen and Peter Norton, Santa Monica

Phoenix Art Museum

Lari Pittman

Regen Projects, Los Angeles

Andrew and Janet Schwartz

The John L. Stewart Collection, New York

United Yarn Products Co., Inc., Arthur G. Rosen

Whitney Museum of American Art, New York City

Several anonymous lenders